BLACK AMERICA SERIES

ORLANDO
FLORIDA

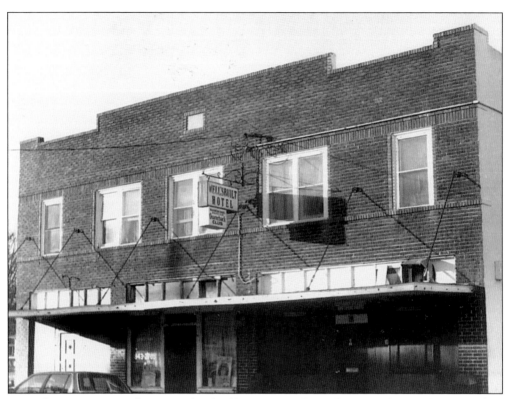

Dr. William Monroe Wells received a building permit from the City of Orlando in 1926 to construct the Wells'Built Hotel, which provided lodging to African Americans during an era of segregation when other accommodations were not available to them. Entertainers who performed at the South Street Casino next door to the Wells'Built often checked into the hotel after their performances were over. The Wells'Built provided lodging to luminaries such as Thurgood Marshall, Ella Fitzgerald, Count Basie, and Jackie Robinson. The hotel closed in the early 1970s and was reborn in the year 2000 as the Wells'Built Museum of African American History and Culture. The Wells'Built is listed on the National Register of Historic Places.

(Front Cover) This photograph was taken during a leadership meeting of African Americans in the early 1950s. Among those identified pictured here are Atty. Paul C. Perkins, Dr. Richard V. Moore, president of Bethune Cookman College Dr. William Monroe Wells, Dr. I. Sylvester Hankins, Mrs. Otelia Frazier, Mrs. Mary Hodge, Mr. William Nixon, Rev. N.G. Staggers, Mrs. Minnie Davis, Mrs. Thelma M. Speight, Mr. Z.L. Riley, Mr. Theodore Rose, Dr. George P. Schanck, Dr. A.L. Bookhardt, Mr. Max Starke Jr., Mr. Wilts Alexander, Mr. Herndon Harrison, Mrs. Perrine Hubert, Mrs. Marguerite Rigsbee, Mr. William Maxey, and Mr. Frank Otey.

(Back Cover) In the absence of organized recreational activities in Orlando, young people amused themselves in a variety of ways. Adolescents are shown playing on railroad tracks in the early 1900s.

ORLANDO
FLORIDA

Geraldine Fortenberry Thompson

ARCADIA
PUBLISHING

Published by Arcadia Publishing
Charleston, South Carolina

Printed in the United States of America

Library of Congress Catalog Card Number: 2003105144

For all general information contact Arcadia Publishing at:
Telephone 843-853-2070
Fax 843-853-0044
E-Mail sales@arcadiapublishing.com
For customer service and orders:
Toll-Free 1-888-313-2665

Visit us on the Internet at www.arcadiapublishing.com

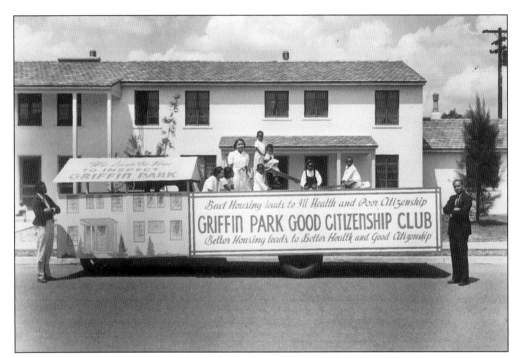

Griffin Park opened in 1940 as Orlando's first housing project for African Americans. The project provided 174 units. Many families who previously lived in Jonestown, the settlement for blacks located at South and Bumby, relocated to Griffin Park. A housing project for whites was built on the location of the former Jonestown. Griffin Park was named for Charlie Griffin, a former slave who was born on November 26, 1836. Charlie Griffin was a medicine man who used roots and herbs to cure illnesses. He died in 1939 at the age of 103 and was buried in the Greenwood Cemetery on March 20, 1939. Griffin Park is listed on the National Register of Historic Places.

CONTENTS

ACKNOWLEDGMENTS

Two organizations have played a significant role in uncovering, capturing, and preserving the history of African Americans in Orlando for the benefit of future generations. I have been a member of both—first, the Central Florida Society of Afro American Heritage and second, the Association to Preserve African American Society, History and Tradition, Inc. (PAST). To the initial work begun by the Central Florida Society of Afro American Heritage, PAST, Inc. has added significantly to make available a body of knowledge regarding the achievements of African Americans in the Orlando area. I have long felt an obligation to complete the work that many of us started and I regard this book as a step in that process. I owe a deep debt of gratitude for the work of many who made this volume possible.

The wisdom and memory of many people enabled me to find the answers to puzzling questions and to locate images of individuals who were stalwarts in this community. I wish to thank Mrs. Audrey Ellis Tillinghast, Mrs. Betty Bradley Smith, Mr. Rufus Brooks, Dr. Alzo J. Reddick, Mrs. Linda Reddick, Judge James E. Perry, Atty. Reginald Hicks, the Florida State Archives, my husband Judge Emerson R. Thompson Jr., Mr. James W. "Chief" Wilson, and Atty. and Mrs. Norris Woolfork for the vital information they provided. I express gratitude to Valencia Community College for housing a great part of this collection for many years, to my Sisterhood of Alpha Kappa Alpha Sorority, Inc. for making people all over the world aware of the Wells'Built as an Orlando resource during the 2002 Boule, and to my sisters in Linkdom for your tremendous recall, financial support, and ready willingness to respond to my queries.

The love and support I have been shown by my family during this endeavor have sustained me during times of difficulty and frustration. With the passing of my father, Vardaman, in 1976, my brother, Willie, in January of 2001, and my mother, Annie Mae, in March of 2001, I am the remnant that remains of the Fortenberrys who came to Florida in the early 1950s. The strong support of Emerson Jr., Laurise, Emerson III, Elizabeth, John, Renee, Jasmyne, Imani, Kiara, and my extended family has helped me to walk on and do the work that is at hand. I dedicate this book to them.

INTRODUCTION

People of African ancestry came to Florida with the Spanish in the 1500s to settle St. Augustine, the oldest city in America. Accompanying the Spanish were African merchants, soldiers, laborers, and craftsmen. In the 1700s, when Spain was at war with the British, the Spanish king offered asylum to enslaved people who would escape from the American British colonies and come into Florida to defend the territory against attack. Many slaves in colonies around Florida escaped and found freedom in this Spanish-owned land. Florida became a haven for runaway slaves who built alliances with American Indians. Others established themselves in a number of areas including Ft. Mose, the first settlement for free African Americans in this country, near St. Augustine. Around 1840, slaves accompanied the first white settlers who came by covered wagon to the area that was to become Orlando.

The early African-American population of Orlando was primarily concentrated in what is now known as downtown. In the mid-1880s, James Magruder, a white builder, developed the first settlement for African Americans near South and Bumby. The settlement was initially known as Burnette Town but was later called Jonestown in honor of community leaders, Sam and Penny Jones. Andrew Hooper built a group of small cottages known as Hooper's Quarters in 1886 and another settlement was established in what is now known as the Callahan Neighborhood. That area was called by a variety of names including "Pepperhill" and "Black Bottom." It was later named to honor Dr. Jerry B. Callahan, an African-American physician who arrived in Orlando in 1908.

In the early 1900s another development known as the Holden Neighborhood became home to many of Orlando's most prominent African-American residents including physicians such as Dr. Jerry B. Callahan, Dr. Cecil B. Eccleston, Dr. I. Sylvester Hankins Jr., Dr. William Monroe Wells, and Dr. Henry Wooden. What was to become known as Jones High School started in 1895 and served grades one through eight. Later, two elementary schools, Callahan and Holden, served African-American children who lived in the downtown community.

Several churches met the spiritual needs of the residents. Mt. Zion Baptist Church, recognized as the first church for African Americans in the Callahan neighborhood, was established in 1880 and Shiloh Baptist Church opened in 1899. Mt. Pleasant Missionary Baptist Church was built in 1919 and was the first church for African Americans constructed of stone. Ebenezer United Methodist Church built a brick structure in 1927. Church Street, Division Avenue, South Street, and Parramore Avenue were the locations of numerous African-American owned businesses. Mr. Z.L. Riley and Arthur "Pappy" Kennedy organized the Negro Chamber of Commerce in 1946 to promote improvements in the African-American community of Orlando. Thriving businesses included the Wells' Built Hotel, Wallace's Beauty Mill, the South Street Casino, Washington Shores Savings and Loan Association, and Prices' Sewing School.

Residents of Jonestown would be moved from that area in 1940 and many of them relocated to Griffin Park, the first public housing development for African Americans in Orlando. As the African-American community grew, so did the need for housing. As a result, construction of Carver Court began in 1944. A year later, the private residential community of Washington Shores was established. Schools opened in the Washington Shores area as did numerous businesses and recreational facilities. African Americans took leadership roles in developing and improving their communities, and their legacy, highlighted in this book, continues today.

One

TRIALS AND EARLY DAYS

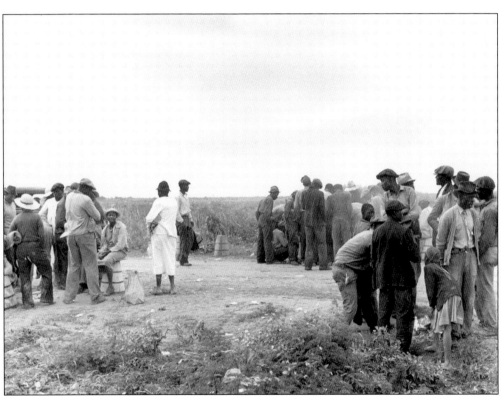

Orlando was an agricultural community in its early development. Field hands are shown here in 1939, preparing to harvest crops. (Courtesy Florida State Archives.)

This page, reproduced from the 1860 Census, shows a sample of Orange County slave owners who enumerated their property. Slaves were shown by age, sex, color, and disability. The number of slave houses provided by slave owners is also shown. Slaves recorded as "m" under color were mixed or mulatto, often resulting from forcible relations between slave owners and slave women.

This page, reproduced from the Eleventh Annual Report of the National Association for the Advancement of Colored People, which was published in 1921, provides an account of the lynching of Mr. Julius "July" Perry in November of 1920. Mr. Perry attempted to vote in the Orange County City of Ocoee. He was lynched in an election-day riot where others were killed and the colored quarters of the town were burned.

Ocoee.—On November 2, election day, a colored man, July Perry, attempted to vote after he had been refused the privilege by election authorities on the ground that he had not paid his poll tax. It is said that Perry returned to the polls with a shotgun, accompanied by several other Negroes; whereupon the white citizens immediately formed a posse and, going to the Negro settlement, set fire to several buildings. According to press dispatches more than twenty buildings were burned and five Negroes, including one woman, perished in the flames. Perry was captured and later taken by the mob and lynched.

The Assistant Secretary was sent to Ocoee to investigate this affair. The following is a summary of his report:

1. That according to statements made by white residents, between thirty and fifty Negroes were killed in election rioting in and near the town of Ocoee, Florida, on November 2, the majority being cremated alive in the buildings that were burned.

2. That by flagrant violation of the terms of the United States Constitution and of local election laws, Negroes in Ocoee, Jacksonville and other Florida towns and cities were prevented from voting.

3. That intimidation by the Ku Klux Klan and other agencies apparently beyond the control of the State of Florida was systematically and persistently practiced against colored people for weeks preceding the election and especially on the Saturday night immediately preceding.

4. That the election rioting about Ocoee resulted not only in the burning of eighteen houses of Negroes, but also in the destruction of a school, a church and a lodge hall.

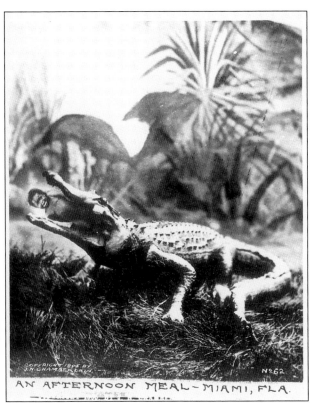

AN AFTERNOON MEAL - MIAMI, FLA.

This Florida advertisement is representative of many negative ads used to promote Orlando and other parts of Florida. This ad is labeled "an afternoon meal" and shows an African-American child in the mouth of an alligator. (Courtesy Florida State Archives.)

Images of African Americans were used in advertisements for various Florida products. This ad shows two boys struggling over a piece of sugar cane. (Courtesy Florida State Archives.)

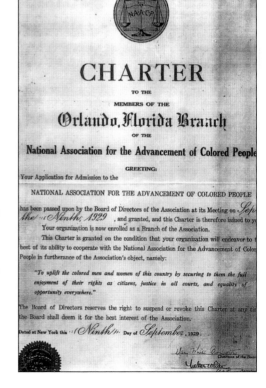

The Orange County Branch of the NAACP was organized to combat lynching in the area. When Mr. Joe Stevens came to Orlando in 1925, he found that people were afraid to join the NAACP for fear of losing their lives or their jobs. He worked with Rev. R.H. Johnson to recruit members. It took them nearly five years to recruit the five members necessary to gain a charter. The national body granted a charter to the group on September 9, 1929. (Courtesy Rufus Brooks.)

Harry T. Moore, in the nearby town of Mims, was an organizer for the Florida branches of the NAACP. He advocated equal pay for black and white teachers and organized the Progressive Voters League in Florida. In 1951, he called for a murder indictment against Sheriff Willis McCall who had killed and seriously wounded inmates in his care. On Christmas night, 1951, a bomb was placed under the bedroom of the Moore's home. Moore died on the way to the hospital and his wife, Harriette, died nine days later. No one was ever tried or convicted for the murder of these two Civil Rights martyrs. (Courtesy Florida State Archives.)

African-American men and women are shown gathered in Orlando in the 1880s. (Courtesy Florida State Archives.)

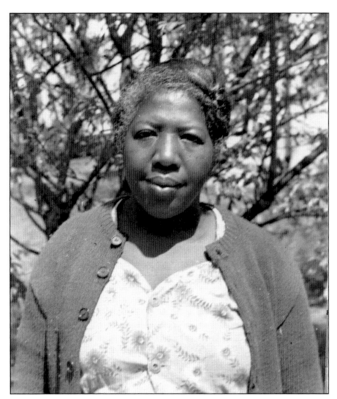

Many women worked as domestics for white families in the area. Becky Davis, born in 1890, was a maid and cook for the Nat Burman family. She was a specialist at preparing strictly Kosher Jewish meals. Becky Davis worked for the Burman family from 1909 until 1970. (Courtesy Florida State Archives.)

Many women worked as laundresses, handling laundry for well-to-do people in the area. A woman is shown in 1929 boiling clothes as young children sit nearby.

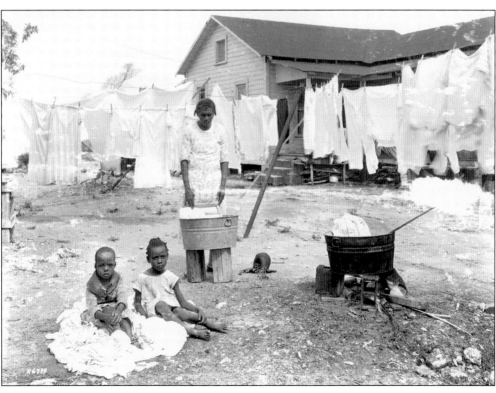

Many agricultural workers did not have horses. Yet, in order to have food for themselves and their families, they plowed the fields for planting. A man is shown here pulling a plow as a woman pushes it into the earth. (Courtesy Florida State Archives.)

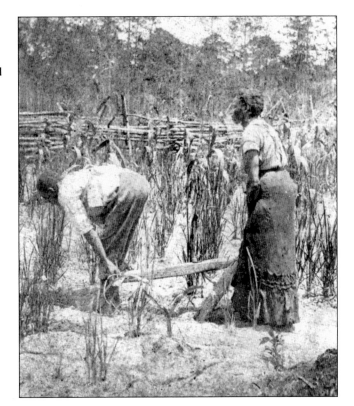

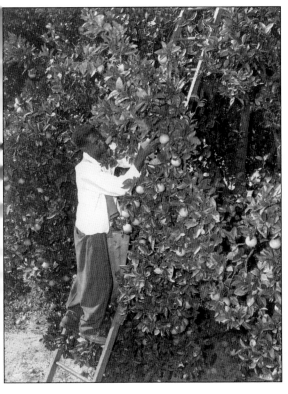

Orange County, the name of Central Florida's largest county, aptly indicates the importance of oranges and other citrus to the economy of the area. A man is shown here in Orlando picking oranges. (Courtesy Florida State Archives.)

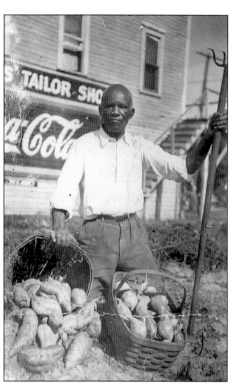

C.T. Williams, of an Orlando pioneer family, is shown here with a crop of sweet potatoes.

Sugar cane was a major crop in the area. A man is shown here straining molasses. (Courtesy Florida State Archives.)

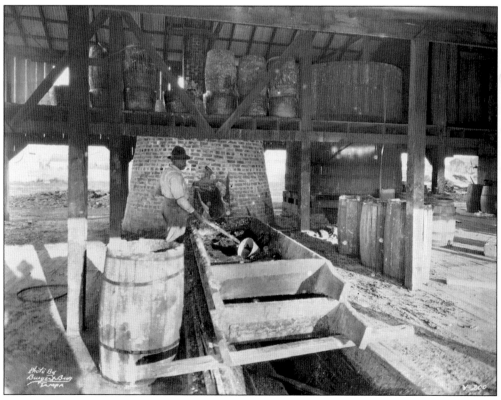

African Americans were trained and skilled in a variety of building trades. Pictured in the early 1900s is a group of black plumbers. (Courtesy Florida State Archives.)

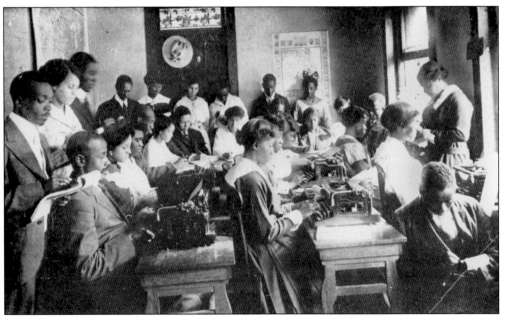

The Walker Business School provided vocational training in subjects such as beauty culture and typewriting. Orlando businesswoman L. Claudia Allen was a student at the Walker Business School. Students are shown here in typewriting class. (Courtesy Florida State Archives.)

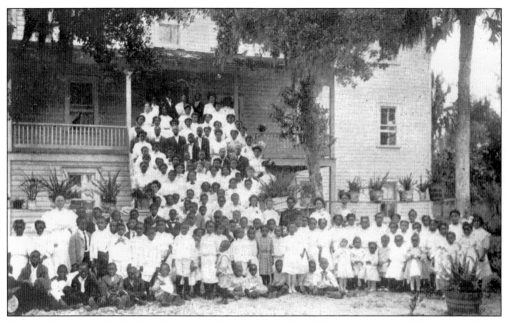

Few institutions offered education beyond grade school to African Americans. Orlando residents supported and enrolled their daughters in the Normal School for Girls started by Dr. Mary McLeod Bethune in 1904 in nearby Daytona. The institution would later become Bethune Cookman College. (Courtesy Florida State Archives.)

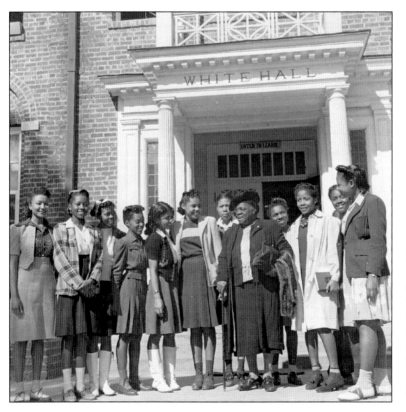

Dr. Mary McLeod Bethune often met and talked with her students. She is shown here in the mid-1900s speaking with some of them. (Courtesy Florida State Archives.)

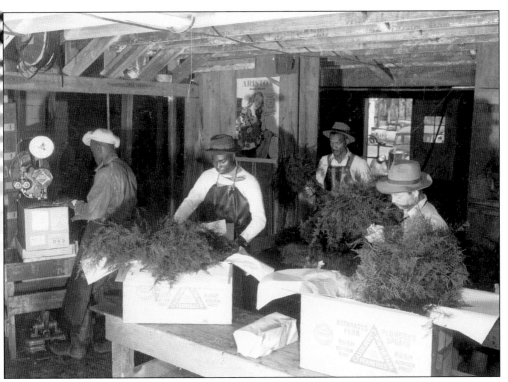

Central Florida produced a variety of crops, including celery, for distribution throughout the country. Men are shown here in the early 1900s packing fern. (Courtesy Florida State Archives.)

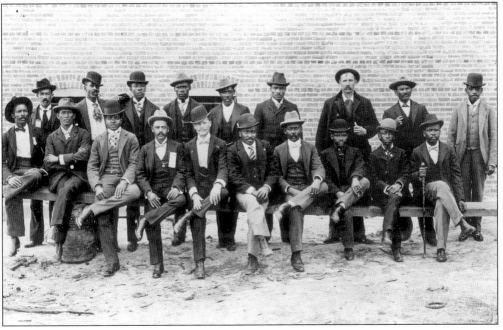

African Americans were trained and skilled in a variety of building trades. Pictured in the early 1900s is a group of bricklayers. (Courtesy Florida State Archives.)

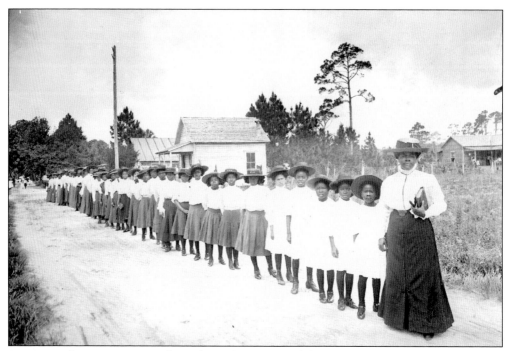

Access to education was very limited. Students traveled from surrounding areas and lived in rooming houses to attend Jones High School. Boarding facilities were provided at Hungerford Normal and Industrial School in Eatonville, Crooms Academy in Sanford, and the Daytona Normal School for Girls in Daytona Beach. Dr. Bethune is shown here in the early 1900s leading a group of students. (Courtesy Florida State Archives.)

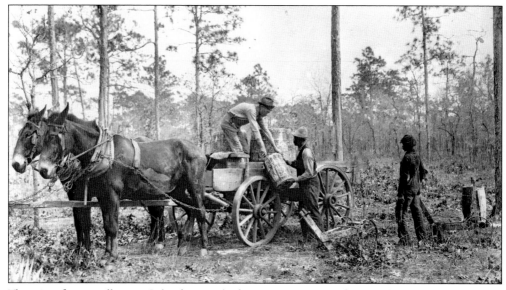

The pine forests all over Orlando supplied great quantities of sap, which was turned into turpentine, a major product of the area. These men are shown working with turpentine. (Courtesy Florida State Archives.)

Two

PIONEERS, HOMES, AND NEIGHBORHOODS

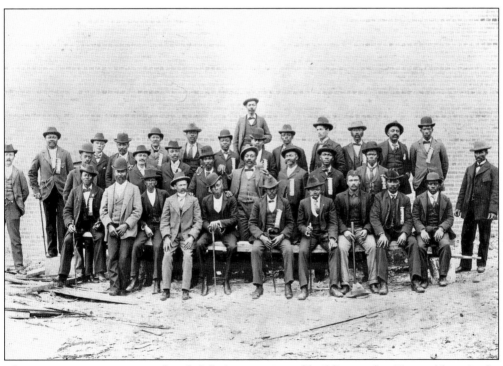

African Americans were trained and skilled in a variety of building trades. Pictured here in the early 1900s is a group of carpenters. Many of the homes in Orlando were built by members of this group. (Courtesy Florida State Archives.)

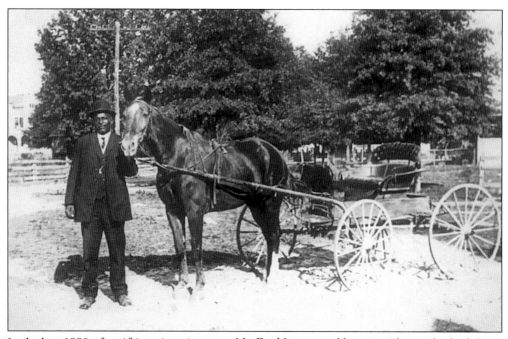

In the late 1880s, few African Americans could afford horses and buggies. Those who had them, such as Moses Crooms Jr., could make a profitable living moving people and goods from one location to another. Moses Crooms Jr. is pictured with the horse and buggy he used in his business as a drayman.

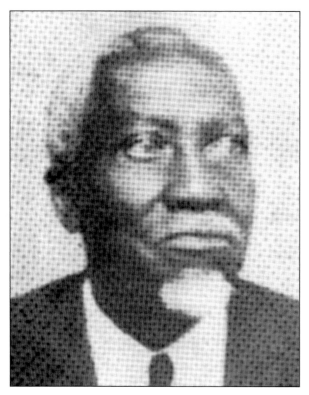

The Lancasters came to Orlando in 1887. They were active in the Mt. Zion Missionary Baptist Institutional Church. Rev. William Lancaster was a minister. The Lancaster family Bible is displayed at the Wells'Built Museum of African American History and Culture.

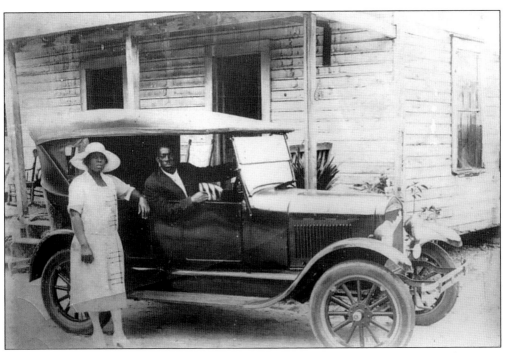

Mrs. Annie Mae Spaulding was one of the first African-American beauticians in Orlando. She is shown here in the early 1900s with Mr. Dan Hightower seated in an automobile.

Mrs. Lucy Lancaster had 15 children. She and her husband, Rev. William Lancaster, bought over an acre of land between Bentley and Livingston on Westmoreland Drive, which was formerly called Reel Street. The Lancasters raised cows, chickens, and horses. One of their children, Mrs. Katherine Lancaster Hodge, who was born in 1899, continued to live at the family home where she celebrated her 103rd birthday in 2002.

Virginia Crooms Howard Preston was born to Moses Sr. and Daphney Crooms in Orlando. Mrs. Preston was seamstress to top white socialites in Orlando—a business she later expanded to include custom upholstery and draperies.

Rev. Alfred C. Crooms was pastor of Bethlehem Baptist Church when it was located in Jonestown. He was one of the seven children of Moses Sr. and Daphney Crooms, and he served as pastor of Mt. Zion from 1945 until 1946. Reverend Crooms was one of the first African-American mail carriers in Orlando.

I. Sylvester Hankins Jr. was born in Orlando in 1895. He attended Johnson Academy through eighth grade, which was the highest level of education offered to African Americans at that time. When he graduated from Johnson Academy in 1910, he went to Edward Waters College in Jacksonville for further study. Edward Waters College was a boarding school that served 150 to 175 students. Hankins worked in Orlando as a paper boy to earn money to attend Edward Waters and is shown here as an adolescent in the early 1900s.

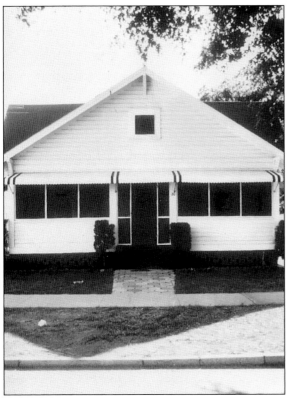

Wesley and Amanda Cosby were ex-slaves who came to Orlando from Georgia. Early city directories show they operated a saloon on Church Street and established an ice delivery business, which was managed by their children. Wesley and Amanda Cosby are the parents of Felix Cosby, who was born in Orlando in 1909. The Cosbys built this home at 30 North Parramore. In 2003, Felix Cosby was very active in the Orlando community.

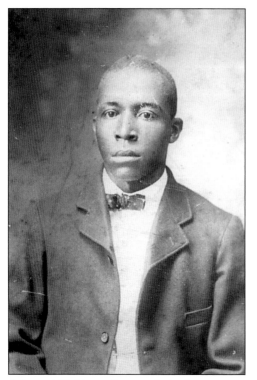 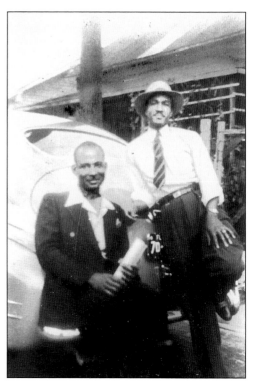

(above, left) Moses Crooms Jr. is shown as a young man.

(above, right) Theodore "Brother" Crooms and Bill Williams lean against a car. Theodore was born in Orlando in 1910 and was the grandson of Moses Sr. and Daphney Crooms. He worked in hotel service, spending winters in Florida and summers in Virginia.

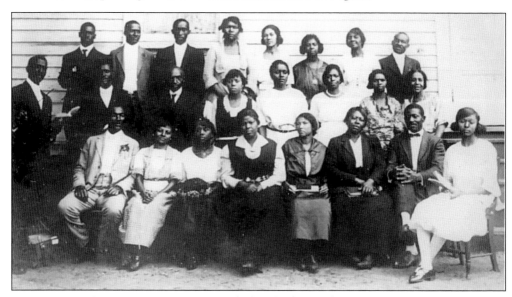

Moses Crooms Sr., a master carpenter, taught his children to be industrious. Daphney Williams Crooms taught her children to read and write and stressed education. Crooms family members became leaders in Orlando in a variety of areas. They are pictured here in the early 1900s.

Mrs. Callahan assisted her husband, Dr. Jerry B. Callahan, to build and operate a professional office building and medical practice on the corner of West Church and Hughey. The Callahans lived upstairs and rented office space in their building, which was erected in 1922. Mrs. Callahan was very involved in charity and civic work. A public parking garage now sits on the property owned by the Callahans.

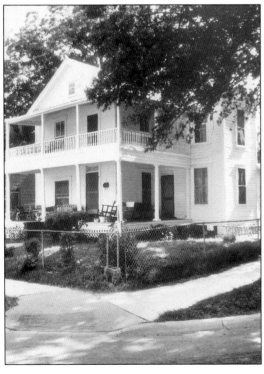

Community leader and businessman Gabriel Jones built this house in 1907. Mr. Jones owned a grocery store that was listed in the Orlando City Directory in 1887. The home, located at 50 North Terry Street, was built for his wife, Clara. The home was considerably larger than others built during that day. Mr. Jones's intent was to board tenants to supplement his income. The Gabriel Jones House boarded tenants from Africa, the Caribbean, and other parts of the world. The house was demolished as development began in the Parramore area.

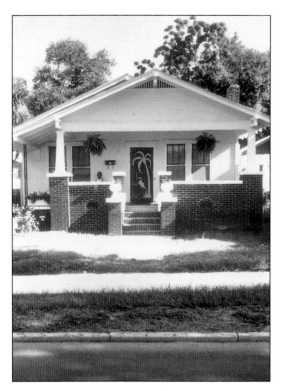

Mrs. Viola Tillinghast Hill hired Mr. James Murell, a black general contractor, to build this home at 626 West Washington Street after her husband, Rev. H.K. Hill, died. She shared this home with her brother, Prof. Sidney Tillinghast, and African-American pilot Bessie Coleman. Dr. Mary McLeod Bethune was a frequent guest in the Hill/Tillinghast House. In the 1940s, the home was the site of a sewing school for young women funded through a program instituted by President Roosevelt, who considered Dr. Bethune a part of his Colored Cabinet. In 2003, the home was listed for sale.

Mr. Moses Crooms Sr. and his wife, Daphney, built this home in 1905. Moses Sr. was born in 1851 and was a slave on the Goodwood Plantation in Tallahassee, owned by Daniel and Elizabeth Croom. The 1850 Census showed that the Croom family owned over 4,000 acres of land from North Carolina to West Florida. After Emancipation, Moses took his master's last name and made it plural. He and Daphney left Tallahassee for Monticello, Florida and a short time later they settled in Orlando at 504 West Washington Street.

Dr. Cecil B. Eccleston was a graduate of the Meharry Medical School of Dentistry. He came to Orlando in 1925 and built this home at 747 West Jackson Street. Dr. Eccleston donated a portion of the land needed for a hospital for crippled African-American children. The facility was called the Eccleston Hospital.

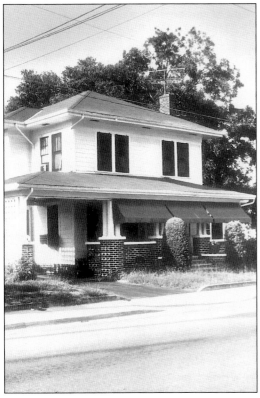

Dr. William Monroe Wells built this home at 407 West South Street in 1924. He and his wife, Clifford Irene, hosted individuals such as Thurgood Marshall and Jackie Robinson in their home. This house was moved in 2001 and became a part of the Wells'Built Museum Complex at 511–519 West South Street.

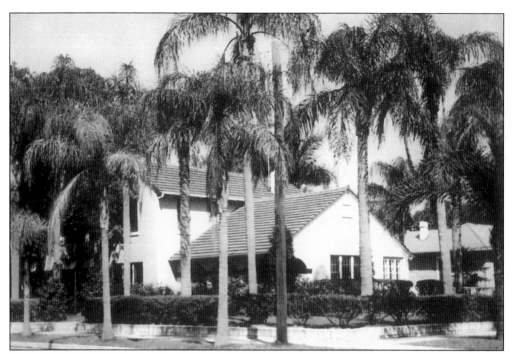

Dr. I. Sylvester Hankins Jr. built this home at 219 Lime Street in 1935. As a civic leader, Dr. Hankins served on the bi-racial relations advisory board of two mayors. He invested financially in an effort to develop homes in Washington Shores. When his home was built, Dr. Hankins landscaped it with 40 palm trees. (Courtesy James Perry and Reginald Hicks.)

Pictured is the living room of the Hankins home where the couple hosted parties and fund-raisers for charitable causes. Mrs. Hankins was very involved in the Orange County Branch of the NAACP and the Links, Inc. Orlando Chapter. (Courtesy James Perry and Reginald Hicks.)

Pictured in the 1930s are dwellings in Orlando typical of some in which African Americans lived before the construction of Griffin Park. The United States Housing Authority allocated $800,000 for the construction of Griffin Park in the late 1930s. (Courtesy U.S. Housing Authority.)

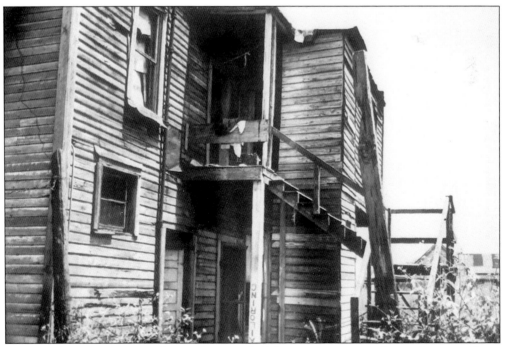

The United States Housing Authority photographed these structures, which were home to African Americans in the 1930s. (Courtesy of U.S. Housing Authority.)

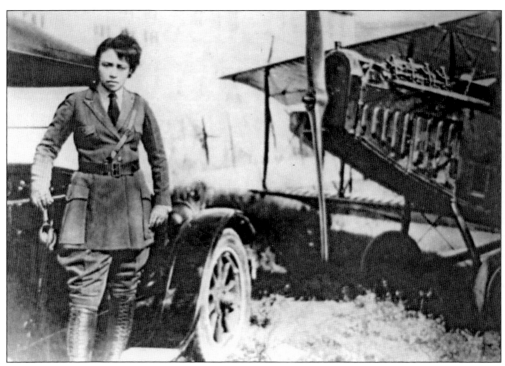

Bessie Coleman, America's first black pilot, had made her home in Orlando with Reverend and Mrs. H.K. Hill prior to her death in a flying accident in 1929.

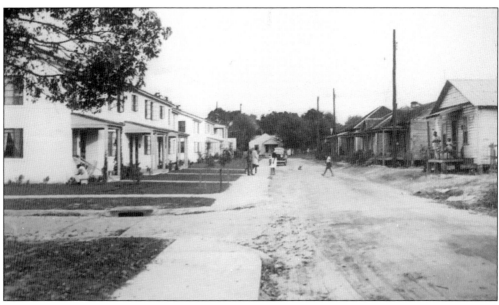

This photograph of Griffin Park shows wood frame shotgun houses across the road. The wooden structures were eventually replaced with concrete block buildings. In a slave narrative compiled during the Federal Writer's Project in May 1937, Charlie Griffin said he was born in Richmond, Virginia and raised by his master, Mr. McKinna, who owned 12 plantations. When his master joined the Confederate Army in 1861, Charlie Griffin said he went with him as a body servant.

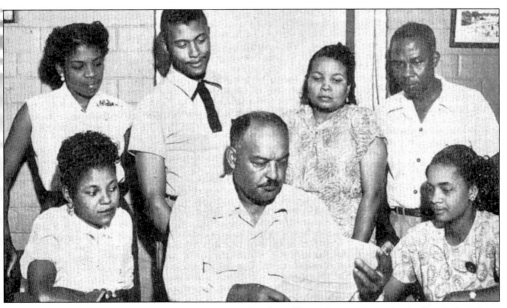

Mr. James B. Walker was supervising manager of colored housing projects, including Lake Mann Homes, Murchison Terrace, Griffin Park, and Carver Court. Mr. Walker is seated in the middle. Seated on his left is Mrs. E. Leona Jackson and to his right is Mrs. Hazel Pete. Standing, from left to right, are Mrs. Thelma Reed, Mr. Leroy Adams, Mrs. Lillian E. Dudley, and Mr. Benjamin Hubert. The projects provided 810 units to African-American families.

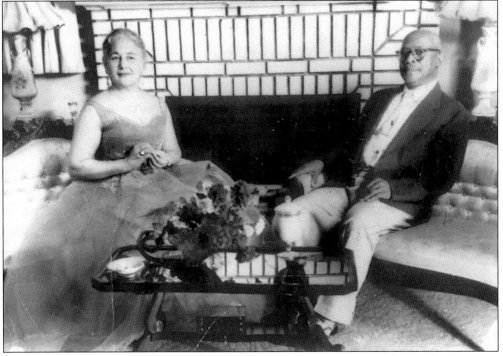

This photograph shows the period furniture that graced the Wells home in the 1940s. Dr. and Mrs. Wells were enthusiastic hosts to social events at their residence.

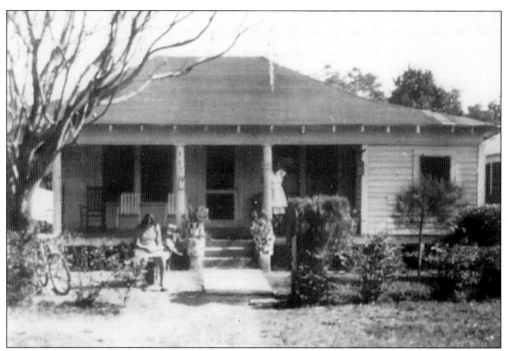

This is the Guinyard family residence. The Guinyards were instrumental in the establishment of Washington Shores.

A number of contractors built homes in Washington Shores. The Washington Shores fourth addition and Luola Terrace were developed by general contractors, Mardis and Hage. The developers promised paved streets, city water, sewers, fire, police protection, and bus service in what they billed as "Florida's most exclusive colored subdivisions."

Three

SPIRITUAL GUIDANCE

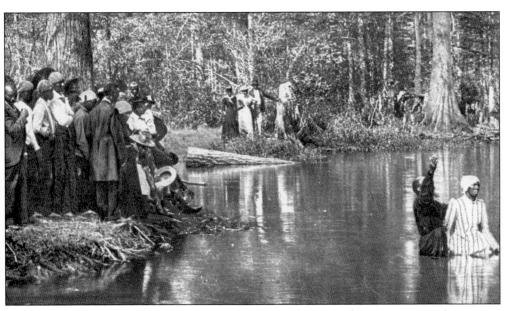

Before African-American churches had baptismal pools, many baptisms in Southern areas took place along river beds or in lakes (and there are more than 30 in Orlando). Here African Americans are shown being baptized. (Courtesy Florida State Archives.)

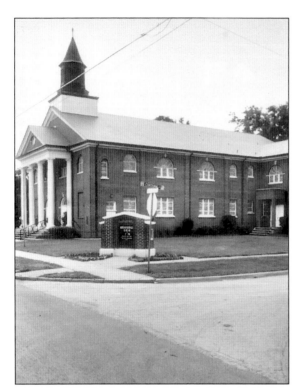

Mt. Zion Missionary Baptist Institutional Church was the first church for African Americans founded in the Callahan neighborhood. It opened its doors in 1880 in a wooden-frame building. A new edifice, pictured here, was built and dedicated in 1962.

Rev. H.K. Hill was pastor of Mt. Zion Missionary Baptist Church from 1910 until 1929. Mt. Zion was a religious and community center. Commencements for Jones High School, which lacked an auditorium, were held at Mt. Zion.

Rev. A. Arnett organized Shiloh Baptist Church in 1899. Pews used in the church in the early 1920s came from African-American churches located in Ocoee, which were burned during an election-day riot. Many leaders in the African-American community were members of Shiloh Baptist Church. They included Arthur "Pappy" Kennedy, Nap Ford, and Willie James Bruton. The church remains at Jackson and Terry.

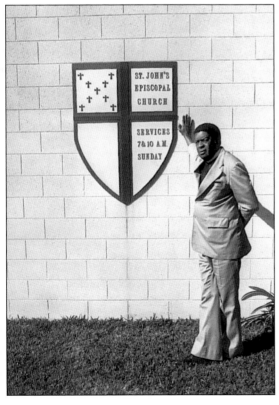

Nelson Wardell Pinder was born in Miami, Florida in 1932. He graduated from Bethune Cookman College and Nashotah House Seminary. When he came to Orlando in 1959 to serve as rector at St. John the Baptist Episcopal Church, he could not get a white cab driver to give him a ride from the airport. He said that the cab driver told him whites and blacks didn't mix in Orlando. Father Pinder said he didn't want to mix, he just wanted a ride. Nelson Pinder worked with other Orlando ministers to integrate playgrounds, little leagues, schools, lunch counters, and parks. In 2003, Nelson Pinder headed the Orange County School Superintendent's African American Advisory Committee. One of his robes is displayed at the Wells'Built Museum of African American History and Culture.

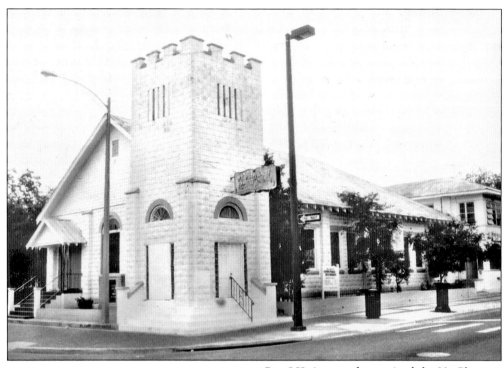

Rev. J.H. Armstead organized the Mt. Pleasant Missionary Baptist Church congregation in 1919. The church building shown here, on South and Parramore, was the first church for African Americans in Orlando built of stone. Members of the congregation formed the stones used in the construction of the church by hand. Mt. Pleasant is now located at Prince Hall and Bruton.

This young girl shown in the early 1900s prepares for confirmation.

Mrs. Viola Tillinghast Hill, wife of Rev. H.K. Hill of Mt. Zion, served as a leader in the State Baptist Convention. She entertained outstanding women such as Dr. Mary McLeod Bethune and Bessie Coleman in her home. An antique lace dress worn by Mrs. Hill is displayed at the Wells'Built Museum of African American History and Culture.

Rev. T.C. Collier is shown below with choir members at Shiloh Baptist Church. Dr. Mary McLeod Bethune was a frequent speaker at Shiloh Baptist Church.

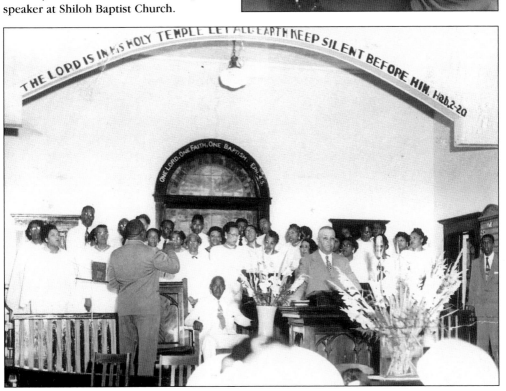

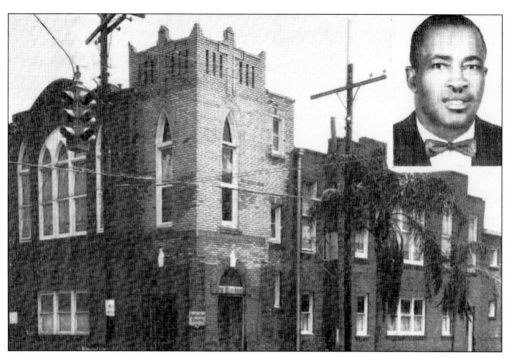

The Ebenezer United Methodist Church was built at the corner of Church and Terry in 1927. The church later moved to Goldwyn Avenue. The Rev. E.H. Johnson was pastor in the late 1950s.

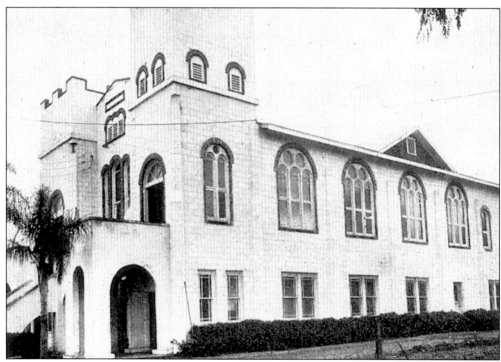

St. Mark African Methodist Episcopal Church was located at 750 Avondale before moving to Bruton Boulevard. The Rev. John L. Wallace pastored the church in the late 1950s.

Mt. Olive African Methodist Episcopal Church was located at 418 West Washington before moving into new facilities on West Church Street. Rev. J. Wesley Jones pastored the church in the early 1950s. Mt. Olive was the church home of Dr. William Monroe Wells.

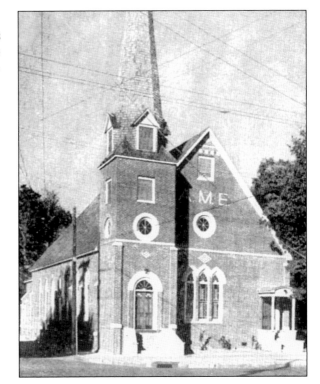

Pictured below is Carter Tabernacle on Westmoreland and Bentley, where Rev. O.R. Jackson was pastor in the 1950s. The church later moved to Cottage Hill Road and John Young Parkway. Carter Tabernacle was named for one of its pastors who later became a bishop.

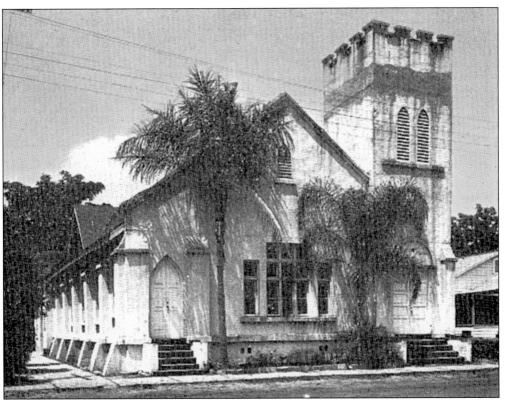

Rev. T.C. Collier is shown in the early 1950s. He served as pastor at Shiloh Baptist Church from 1922 until 1959. He conducted a week long revival in Atlanta, Georgia for a friend, Daddy King. During this revival, after one of Reverend Collier's sermons, Martin Luther King Jr. joined the church.

Booker T. Reddick is pictured here with members of the A.M.E. Church. He is standing fourth from the left. (Courtesy Linda Reddick.)

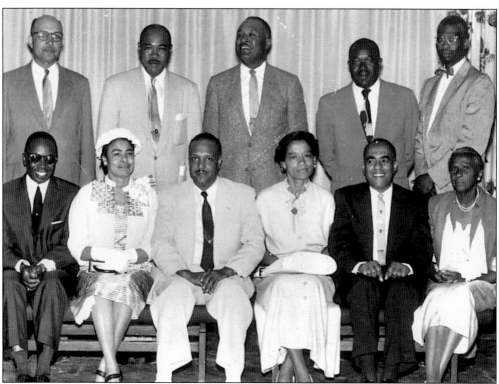

Four

EDUCATION

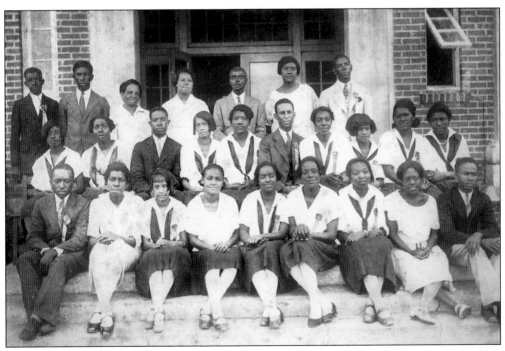

The 1926 graduating class of Jones High School is shown. Even though it was called a high school, Jones served grades one through ten at that time. Mr. Felix is shown seated on the left of the front row. (Courtesy Felix Cosby.)

Johnson Academy, which opened in 1895 on the southwest corner of Garland and Church Streets, later moved to Parramore and Jefferson. A new facility, the front of which is shown here, was built at Parramore and Washington in 1921. The school was then named Jones High School. The building now houses the Callahan Neighborhood Center.

Pictured are members of the 1937 Jones High School football team.

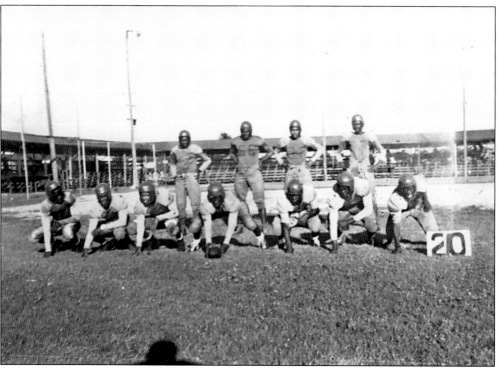

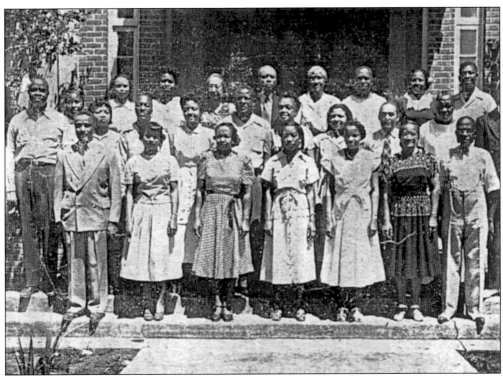

These are early teachers at Jones High School. From left to right, they are (front row) Mr. W. Davis, Mrs. E. Moore, Mrs. R. Jones, Mrs. C. Mitchell, Mrs. J. Brown, Mrs. E. Wooden, and Mrs. K. Amarty; (middle row) Mr. R. Gripper, Mrs. C. Byrd, Mr. G. Jones, Mrs. A Felder, mr. G. Fort, Mrs. I. Baker, Mrs. C. Winson, Mr. W. Busch, Mr. M. Levain, and Principal C.W. Banks; (back row) Miss D. Duffy, Mrs. E. Coleman, Mrs. A Rogers, Mrs. C. Logan, Mr. G. Richardson, Mrs. E. Brayboy, and two unidentified people.

Mr. Felix Cosby, born in Orlando in 1909, was an educator for 42 years in Central Florida. He started the education program at Washington Shores Elementary School, which opened in 1957 with an enrollment of 811 students. He also organized the Orlando All Stars baseball team in 1937. The All Stars competed with such teams as the Pensacola Tigers, the Sanford Black Cats, the Atlanta Crackers, and the Kansas City Monarchs. Mr. Cosby graduated from Jones in 1926.

Mr. Wilts Alexander was manager of the Central Life Insurance Company. He brought suit in the state to bring about equalization of teachers' pay.

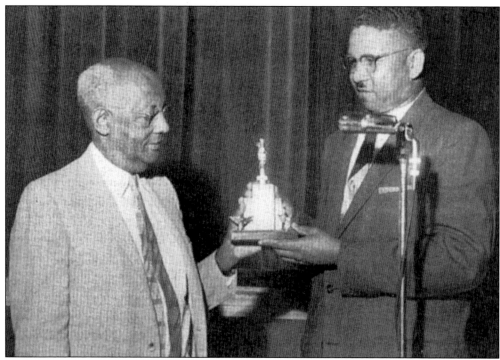

Mr. Z.L. Riley of the Negro Chamber presents a trophy to Mr. Cecil Boston, principal of Jones High School, for the role the school played in the community.

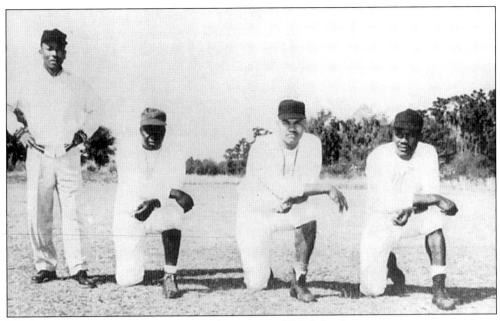

Mr. Felix Cosby is shown with other coaches at Jones High School.

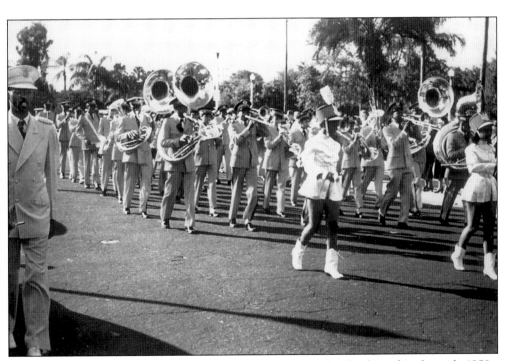

Bandmaster James "Chief" Wilson marches with the Jones High School Band in the early 1950s. Chief was a graduate of Florida A&M University and fashioned his band program after the world-renowned band at that institution.

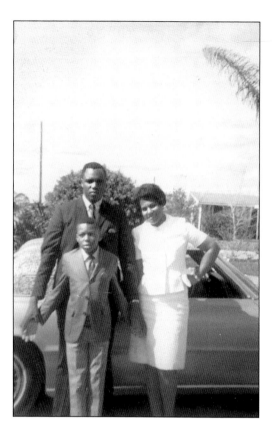

Mrs. Jerry DeShay took her son, James, with her after schools were integrated and she was transferred from Richmond Heights Elementary School to Pinecastle Elementary. The DeShay family is pictured in the late 1960s. (Courtesy James T. DeShay.)

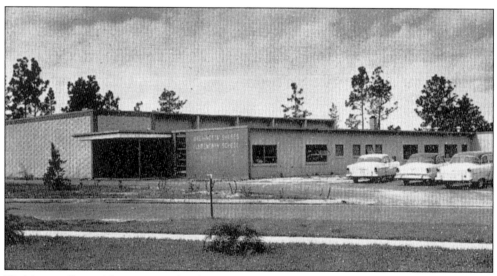

Washington Shores Elementary School opened in 1957 and employed 25 teachers, 5 lunchroom workers, 2 custodians, and a maid. Mr. Felix Cosby was principal of the school, which is located at the intersection of Lake Mann and Rogers Drive in Washington Shores.

Dr. George Lamar Speight was very active in the Jones High Band Parents Association. He is shown here with his daughters, Barbara on the left, infant Thelma in the middle, and Jeannette on the right.

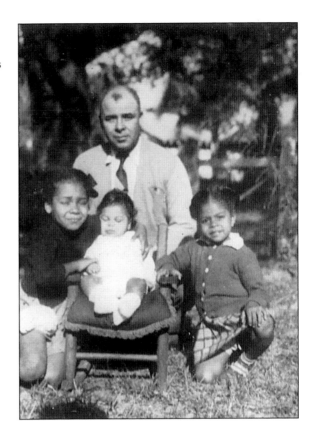

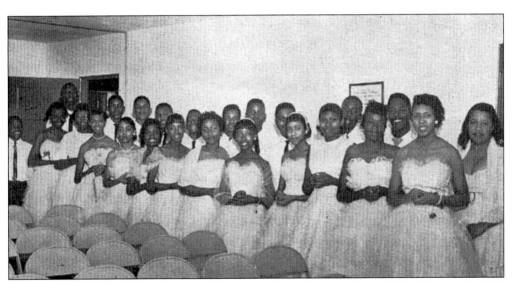

The Jones High School Choir supported a great number of community activities. Pictured in 1958 are Mrs. Leslie Braboy Weaver and members of the choir.

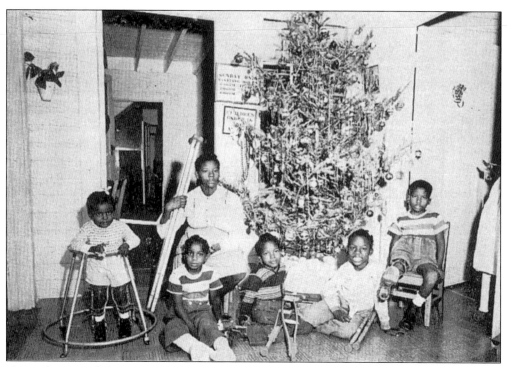

The Eccleston-Callahan School offered training to children with disabilities.

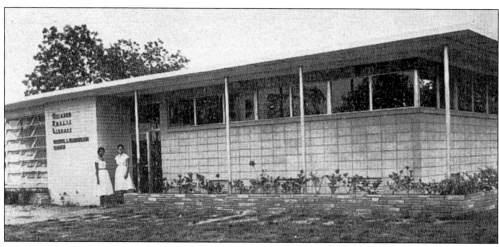

In 1915, the first branch of Albertson's Public Library for African Americans was opened at the school operated by the Episcopal Church of St. John's the Baptist. The branch later moved into this facility at 548 West Jackson Street.

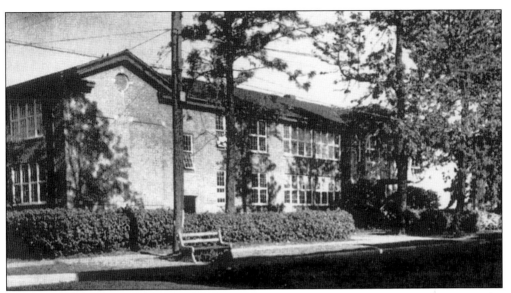

The J.B. Callahan Elementary School was located at 101 North Parramore before moving into the facility at Washington and Parramore, which was vacated by Jones High School when it moved in 1952.

Mr. Frederick Wilson was founding president of the Jones High School Band Association. He was an early African-American mail carrier in Orlando.

The Holden Street School at one point was the only elementary school for African-American children in Orlando. The Holden Street School was located on South Street and Kentucky, which later became Orange Blossom Trail. The facility was later used to house administrative offices of Lynx, the area public transportation system.

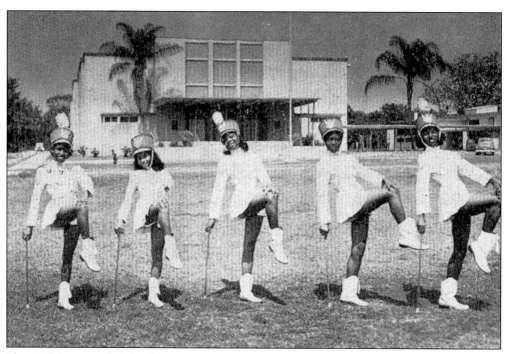

The 1953 Jones High School majorettes shown, from left to right, are Eleanor Hayes, Jeannette Speight, Mary Francis Davis, Marva Cannon, and Willie Lee Mims.

Mrs. Leona Booker was principal of the Eccleston School for Crippled Children.

Jerry Armstead leads the group participating in the Annual May Day Festival at Holden Street School. Leroy Argett and Diane Brown are in the middle, and two unidentified boys are pictured in the rear.

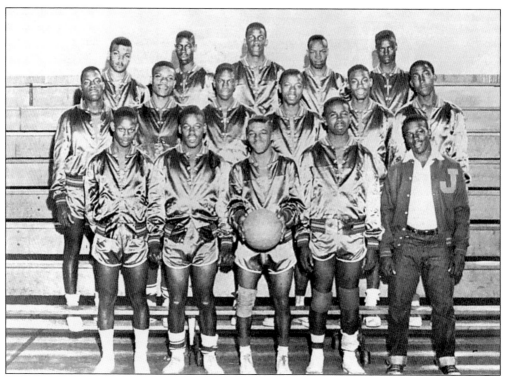

Pictured is the 1955 Jones High School basketball team. From left to right are (front row) Raleigh Smith, Clarence "Choo Choo" Coleman, Elijah Rogers, Harry Ervin, and Albert Richardson, trainer; (middle row) L.C. Jacobs, Levon Guinyard, Augustus Purcell, Albert West, Sylvester Wright, and Otis Hawkins; (back row) Winfred Kennedy, George Robinson (captain), Asa Bankston, Theotis Dawson, and Tommy Horton.

Eccleston Hospital for Crippled Children was dedicated in 1952. The former hospital is now Eccleston Elementary School.

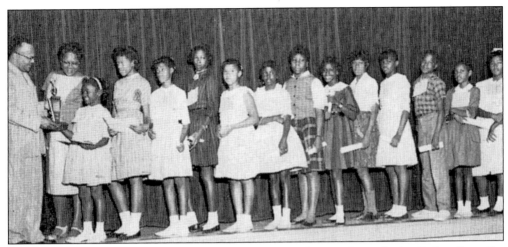

Mr. Felton Johnson and Mrs. Mary Stevenson presented a trophy to Janice Parker from the Holden Street School for first place in the Orange County Spelling Bee. She also received a $100 War Bond.

In 1952, Jones High School moved into a new location at Cypress and Rio Grande. In 2002, the 1952 buildings were demolished and new facilities were built on the same site.

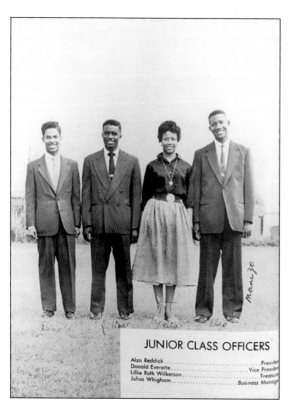

Alzo J. Reddick and Donald Everett were class officers at Jones High School in 1955.

JUNIOR CLASS OFFICERS

Alzo Reddick.................................President
Donald Everette.........................Vice President
Lillie Ruth Wilkerson.........................Treasurer
Julius Whigham.....................Business Manager

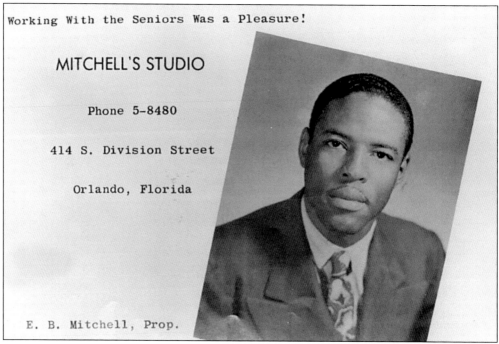

Edgar B. Mitchell took photographs of the seniors at Jones High School. He thanked them in an advertisement.

Kattie Adams, a Jones High School graduate, became the first African American on the Orange County School Board in 1980.

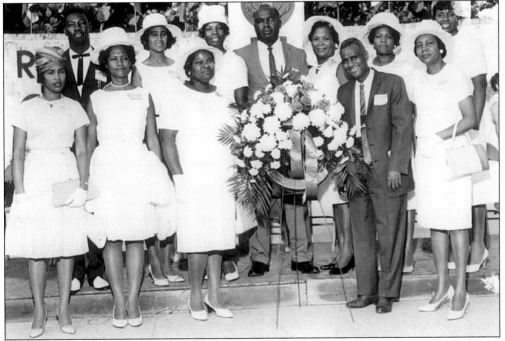

Arthur "Pappy" Kennedy is pictured here with members of the Parent Teachers Association who attended a convention in Miami.

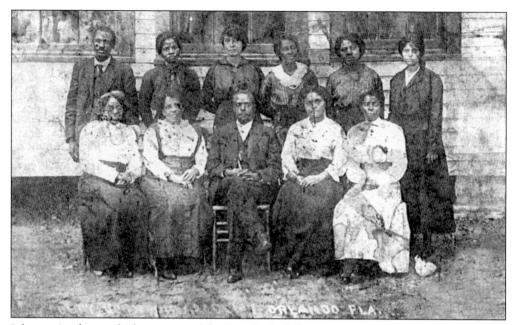

Johnson Academy, which was named for its principal, Lymus Johnson, opened in 1895. It was later moved to Washington and Parramore and become known as Jones High School. Shown here are teachers at Johnson Academy. Standing, from left to right, are Mr. Gruggie, Mrs. Douglas, Mrs. Crooms, Ms. Jackson, Mrs. Hill, and Mrs Hopkins. Sitting, from left to right, are Mrs. Proctor, Ms. Henderson, Prof. L. C. Jones, Mrs. Murrell, and Mrs. Thomas.

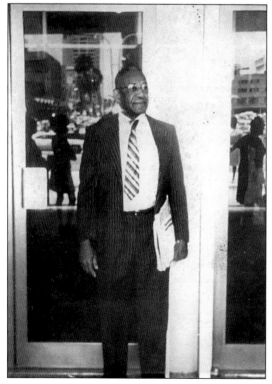

Sidney Riley Tillinghast was born on December 8, 1900 and graduated from Jones High School in 1916. His diploma, on display at the Wells'Built Museum of African American History and Culture, bears the original signature of the principal for whom the school was named, Prof. L.C. Jones. Sidney Tillinghast graduated from Morehouse College in 1923 along with classmates such as Howard Thurman, the first African-American Dean at Boston University, and James M. Nabrit Jr., who taught Thurgood Marshall as a law professor at Howard University. Professor Tillinghast taught at Georgia State College, Savannah State, and Bishop College. He was president of Arkansas Baptist College. He married Audrey Ellis after she was widowed.

Five

CAREGIVERS

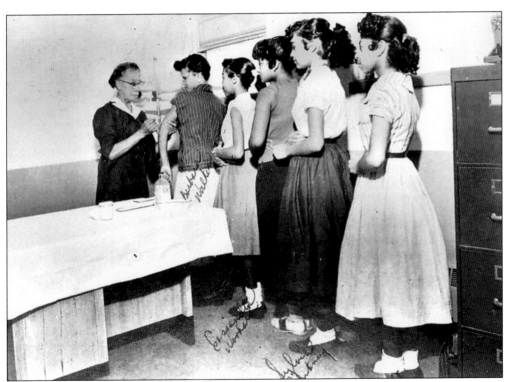

Mrs. Kitty Katurah B. Taylor, a graduate of the Hampton Training School for Nurses, was one of the first African-American nurses to serve the Orlando community. Mrs. Taylor did post-graduate work in the Lincoln Hospital Department of Pediatrics. She began work in 1926 as a staff nurse for the Orange County Health Department, where she worked for 13 years. She later served for 17 years as a school nurse for Orange County public schools until 1956. Mrs. Taylor is shown here preparing to give immunizations to area students.

Mrs. Theresa Manigault Walton was the first African-American staff nurse at Orlando Regional Hospital. Graduating from Jones High School and Florida A&M University, she took additional classes at John Hopkins University and the Veteran's Hospital in Tuskegee, Alabama before joining the staff of Orange General Hospital in 1945. She started her career in the Colored Ward, which was located in the basement of the hospital next to the boiler room. Regardless of whether African-American patients had infectious diseases or were delivering babies, they all were assigned to CW—the Colored Ward. Walton retired from ORMC in 1990 as assistant to the senior vice president and CEO of the hospital.

Dr. Cecil B. Eccleston, a native of Jamaica, started his dental practice in Orlando in the 1920s. He was a leader in St. John's Episcopal Church where he helped to operate a school for African-American children. Dr. Eccleston was active in the Colored Service Men's Organization.

Mrs. Mary Jane Johnson was born July 29, 1904 in Sylvester, Georgia. In 1923, hers was one of the early families to move into Jonestown. She worked as a midwife from 1932 until 1983. During her work as a midwife, she delivered over 1,500 babies, including 4 of her 8 children.

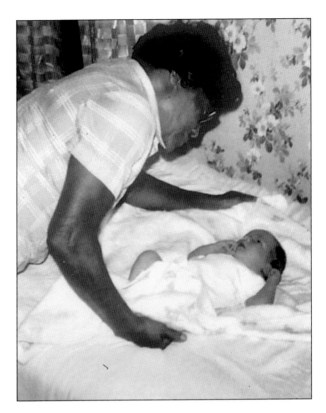

Dr. Robert W. Hunt, dentist, served individuals in the Holden, Callahan, and Parramore communities at his office at 647 West South Street.

Dr. William Monroe Wells was a graduate of Meharry Medical College. He delivered over 5,000 babies in Orlando. For a time during World War II, Dr. Wells was the only African-American physician in the city. He was very involved in the civic and social life of the area as owner of the South Street Casino and the Wells'Built Hotel. He was a leader with the Negro Chamber of Commerce, Mt. Olive A.M.E. Church, and Bethune Cookman College.

Dr. George Lamar Speight, dentist, provided services to the community from his office at 441 North Church Street.

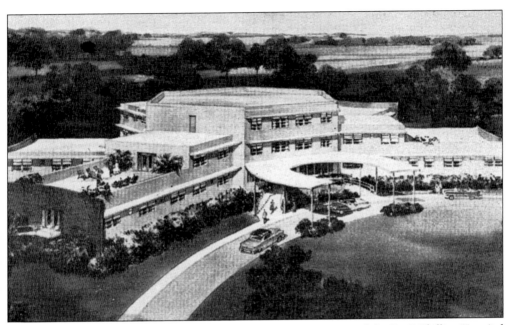

The Florida Sanitarium and Hospital spearheaded the construction of the Dr. P. Phillips Hospital for Coloreds at the corner of Church Street and John Young Parkway near Washington Shores. The hospital opened in 1959 and provided medical, surgical, and obstetrical services. The former hospital is now the Guardian Care Convalescent Center.

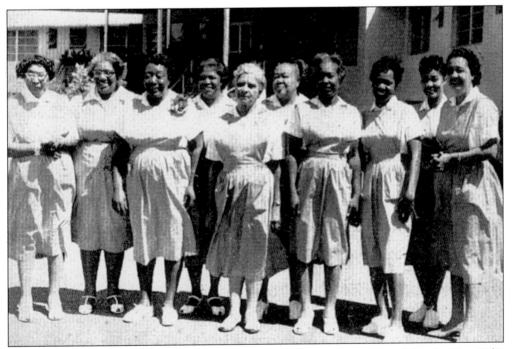

Auxiliary workers act as hostesses for the Dr. P. Phillips Memorial Hospital Day in May 1960. Shown from left to right are workers Jamerson, Ware, Lance, Holt, Jenkins, Brooks, Daetwyler, Murphy, Cox, and Rigsbee.

Dr. Jerry B. Callahan opened his medical practice in Orlando in 1908 after earning a medical degree from Shaw University in North Carolina. He was born on a family-owned plantation in Abbeville, South Carolina on December 9, 1883. He practiced in Orlando for over 40 years, and he was a member of the Orange County Medical Society, the Masons, Shriners, and the Baptist Church. The Callahan Neighborhood is named for him.

Dr. I. Sylvester Hankins was born in Orlando in 1895. His father was the first principal of the Orlando Colored School. He graduated from Howard University Medical School and began his practice in his hometown in 1926. Dr. Hankins was an early president of the Orange County Branch of the NAACP. Hankins Park is named for him.

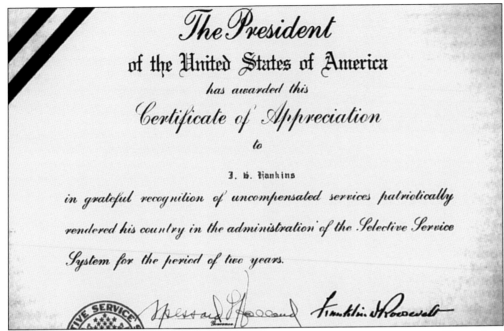

Dr. I. Sylvester Hankins Jr. was a medical examiner for the Selective Service System. He received certificates of appreciation from numerous United States Presidents, including President Franklin Delano Roosevelt, who signed the above certificate. (Courtesy James Perry and Reginald Hicks.)

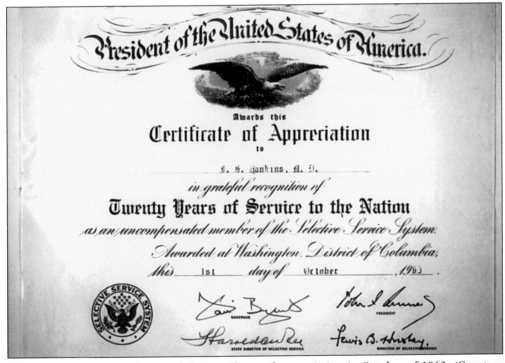

President John F. Kennedy signed this certificate of appreciation in October of 1963. (Courtesy James Perry and Reginald Hicks.)

Dr. George P. Schanck came to Orlando in 1945. He was a graduate of Howard University and Meharry Medical College. A specialist in treating tuberculosis, he served on the staff of area hospitals from 1945 until 1978. He was a director of the Washington Shores Savings and Loans, a member of the Florida Medical Association, a 32nd Degree Mason, a Shriner, and a member of Alpha Phi Alpha and Sigma Pi Phi Fraternities.

Dr. James R. Smith graduated from Northwestern University Medical School. He moved to Orlando in 1940 and shared office space for a time with Dr. I. Sylvester Hankins Jr. Later, Dr. Smith opened his office at 640 W. South Street where he also organized a lying-in hospital where mothers could deliver their babies in clean and safe surroundings. He organized a day nursery in 1966 and in 1962 was instrumental in getting a charter for Washington Shores Savings and Loan Association. Dr. Smith organized the Washington Shores Association for Recreation, known as WASAR. The WASAR building at C.R. Smith and John Young Parkway in 2003 was home to Front Line Outreach Center. The James R. Smith Center is named for him.

Six

BUSINESSES

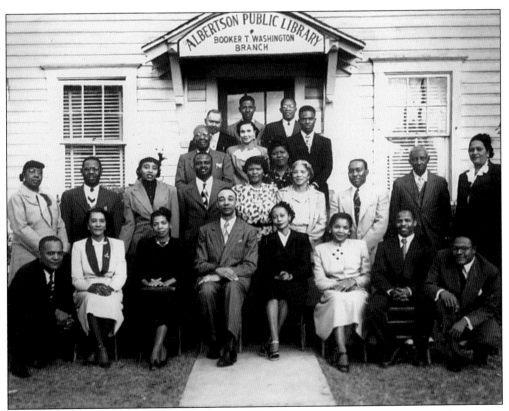

Mr. Theodore Rose and other members of the African American Life Insurance Agents Association gathered in front of the Booker T. Washington Branch of the Albertson Public Library in the 1930s. (Courtesy Dorcas Rose.)

Dr. J. Mark Cox worked as one of the first African-American surgeons in Orlando. He graduated from the College of Medical Evangelists in Luma Linda, California. Florida Hospital and the Seventh Day Adventist Church recruited him to become medical director of the Dr. P. Phillips Hospital for Coloreds, which opened in 1959. He was a director of the Washington Shores Savings and Loan Association and president of the Red Cross, and he was active in the Mental Health Organization.

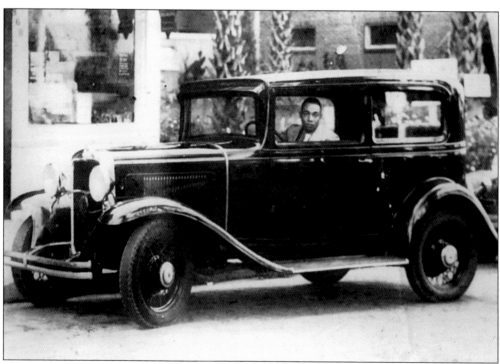

Mr. T.M. Rose, an insurance agent, is shown in his car. (Courtesy Dorcas Rose.)

Mr. T.M. Rose served as an agent for an African-American insurance company and became director of financial aid at Florida A&M University.

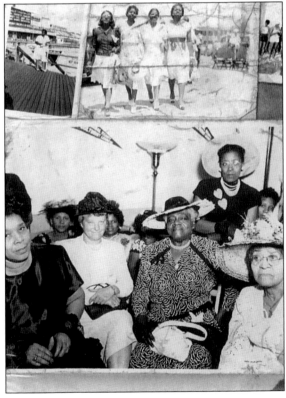

Mrs. Georgia Lee Wallace was an officer in the Southern Beauty Congress and was active with the United Beauty School Owners and Teachers Association, as well as Alpha Chi Pi Omega Sorority, which raised funds to support the Bethune Cookman College Foundation. Mrs. Wallace is shown seated behind and to the left of Dr. Mary McLeod Bethune in the early 1950s.

In 1954, Mrs. Wallace studied in Paris. She is shown with other cosmetologists and members of Alpha Chi Pi, who attended the special institute in France. Mrs. Wallace is the first person in the second row of those photographed.

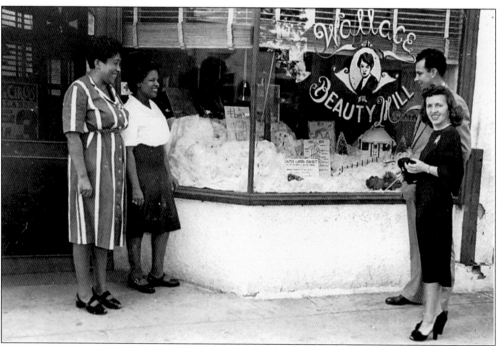

Mrs. Georgia Lee Wallace opened the Wallace Beauty Mill in 1941. She is shown outside her shop, which was located at 557 W. Church Street until November of 1975. Mrs. Wallace is pictured standing second from the left.

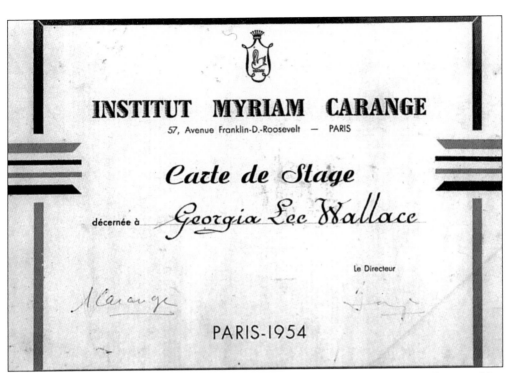

INSTITUT MYRIAM CARANGE

57, Avenue Franklin-D.-Roosevelt — PARIS

Carte de Stage

décernée à *Georgia Lee Wallace*

Le Directeur

PARIS-1954

The director of the Institut Myriam Carange in Paris, France awarded this certificate to Mrs. Georgia Lee Wallace in 1954.

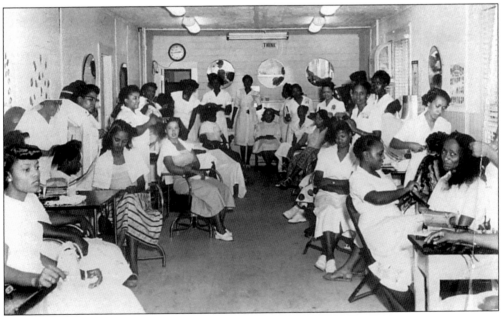

Mrs. Georgia Lee Wallace was one of the most successful businesswomen in Orlando for nearly three decades. Initially, she shampooed, pressed, colored, curled, and styled hair for 50 cents a head. Other cosmetologists also worked with Mrs. Wallace. She and other stylists are shown in the 1950s. Mrs. Wallace was a humanitarian and gave generously to community causes.

71

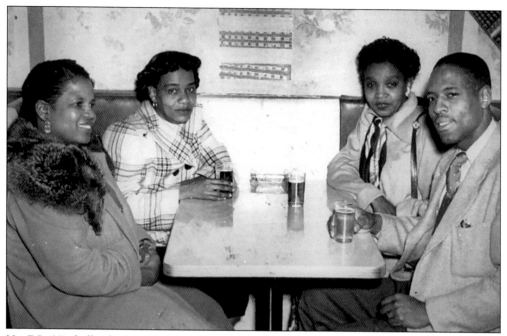

Mr. E.B. Mitchell relaxes with friends, including Mrs. Georgia Lee Wallace and his sister, Mrs. Anne Felder. Mr. Mitchell owned a highly successful photography studio, which was located at 414 S. Division. Mrs. Wallace and Mrs. Felder are seated on the left.

Mr. E.B. Mitchell photographed this couple on their wedding day. In 1963, he accepted a position with the *Orlando Sentinel* and became the first African-American professional to work for the publication. As a photojournalist, E.B. Mitchell photographed happenings in Orlando's African-American community for inclusion in the *Sentinel*'s *Negro Edition*, which was printed on pink newsprint and commonly called "the pink sheets." The *Sentinel* established the E.B. Mitchell Photojournalism Scholarship for Minorities in honor of him.

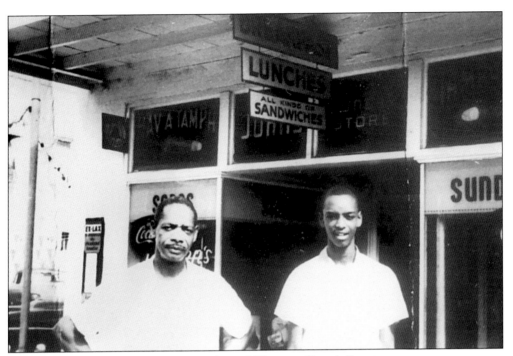

Mr. John Frazier operated Frazier's Sundry and Diner on Church Street.

Ms. Pinkie Price was born in Orlando in 1912. She was an entrepreneur who operated a sewing school, worked with the Lincoln Theater, was a hatcheck girl at the South Street Casino, and taught for the public schools for 20 years. The Prices often boarded entertainers at their home, which was located at 525 W. Jackson Street.

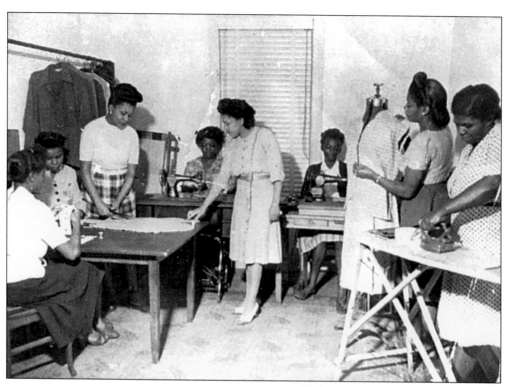

Pinkie Price instructed students at Prices School of Sewing and Tailoring located at 578 W. Church Street.

Mr. B.H. Evans, who was born in Arcadia, Florida in 1902, moved to Orlando in the 1930s. He opened a fish market on Westmoreland Drive and later opened five more throughout the city. In 1959, he bought land on the corner of Henton and Columbia and built Evans Sunoco Station. He also owned the Washington Shores Drive-In Theatre across the street from his Sunoco Station. Mr. Evans was the Most Worshipful Grand Master of Florida's Prince Hall Grand Lodges.

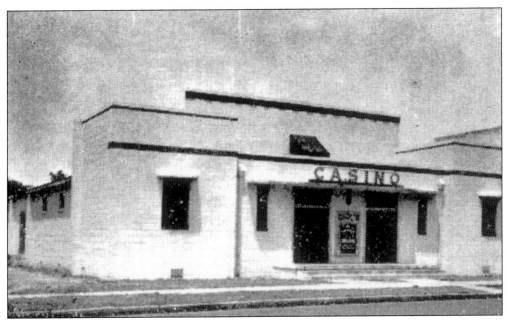

The South Street Casino, located at 519 W. South Street, offered dances and performances by entertainers such as Jimmy Lunsford, Erskine Hawkins, the International Sweethearts of Rhythm, Count Basie, and Duke Ellington. Dr. William Monroe Wells owned the South Street Casino. A fire destroyed a large portion of it, and it was demolished in 1987.

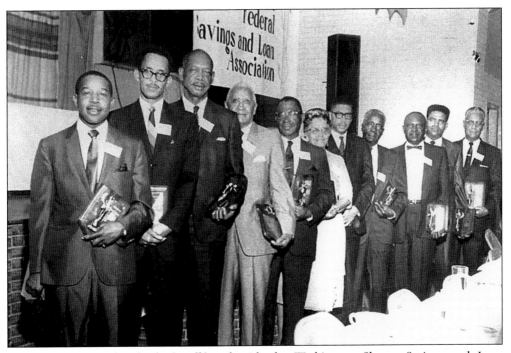

This photograph of individuals affiliated with the Washington Shores Savings and Loan Association was taken in the 1970s. Among those pictured are Paul C. Perkins, Charles Hawkins, John Frazier, I. Sylvester Hankins Jr., Leighler C. Maultsby, P.J. Holt, and Mr. Vereen.

Mr. Charles Hawkins was a manager with the Afro-American Life Insurance Company before becoming president of the Washington Shores Savings and Loan Association.

The owners and staff of Mayhuse Furniture Company are shown here. Mr. Ellis Grant, manager of the company, stands to the far right. For a time, the furniture company was located on the ground floor of the Wells'Built Hotel at 511 W. South Street.

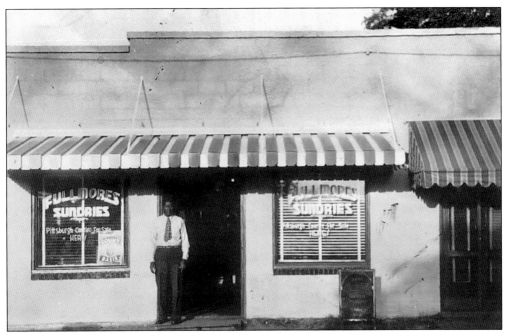

Mr. Fullmore of Fullmore's Sundry is pictured in the doorway of his business. The Sundry also sold issues of the *Pittsburgh Courier*, which featured news about African Americans throughout the nation.

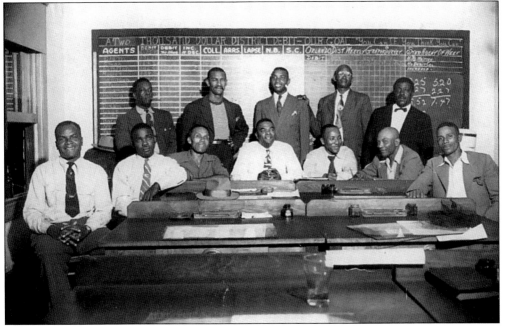

Mr. Felix Cosby is shown here with other agents of the Negro Baseball League. Mr. Cosby, who owned the Orlando All Stars Baseball Team, is seated third from the right.

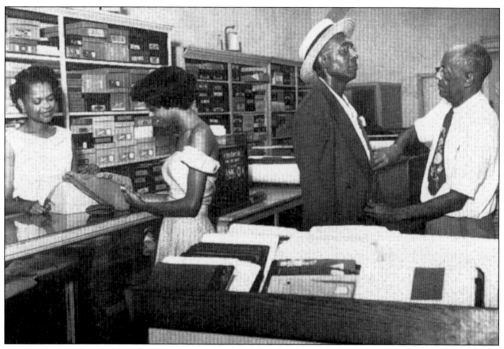

Mr. Zellie L. Riley owned Riley's Men's Shop at 571 W. Church Street. He billed his shop as "a friendly trading center and the gateway to a man's joy." He was president of the Negro Chamber of Commerce, which was headquartered upstairs over his shop. The Riley Building and the sites of other African-American businesses were demolished to make way for the Hughes Supply Complex on Church Street.

Dr. I. Sylvester Hankins, a general practitioner, served his patients in his office located upstairs at 647 W. South Street. Dr. Hankins ended his practice after more than 50 years of service to the Orlando community, and the building became home to the NAACP.

Officials including Charles Hawkins and Dr. James R. Smith review the charter of the Washington Shores Savings and Loan Association, the first bank to be owned and operated by African Americans in Florida. The bank opened at 715 S. Goldwyn Avenue and continues to operate as the Metro Savings Bank. The original sign from the bank, which opened in 1969, is displayed at the Wells'Built Museum of African American History and Culture.

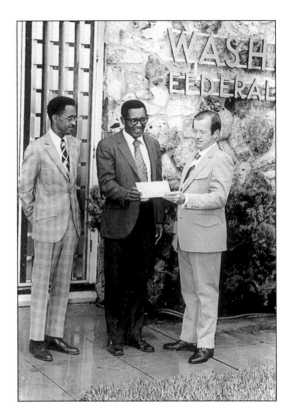

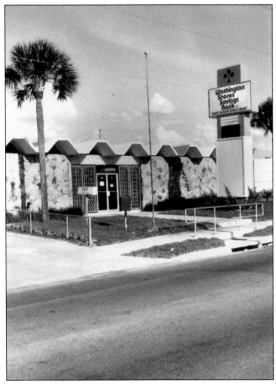

Orlando doctors James R. Smith, J. Mark Cox, George P. Schanck, and Issac Manning worked with Mr. Leighler Maultsby and Atty. Paul C. Perkins to establish the Washington Shores Savings and Loan Association in the 1960s.

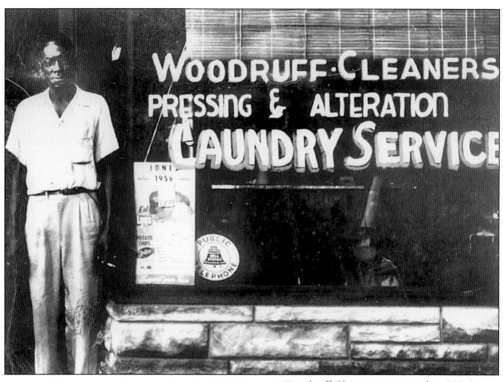

Woodruff Cleaners operated at 208 S. Terry Street. Mr. Woodruff is pictured in front of his business in 1956.

The Woodruffs were active leaders in the Orlando community.

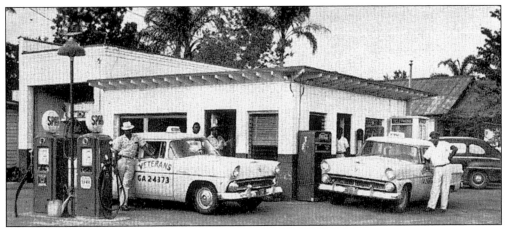

Mr. Willie Pete was proprietor of Veteran's Cab and Service Station located at 445 S. Parramore Avenue. White cab owners would not provide rides to African Americans. Veteran's Cab served African-American residents and visitors to the area.

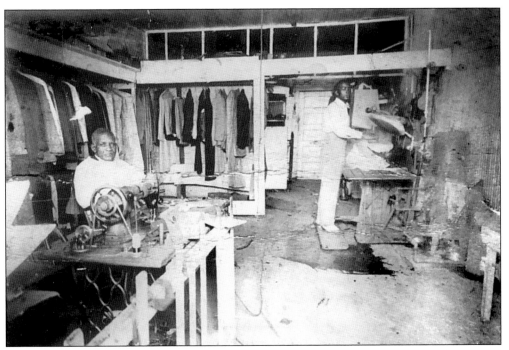

In the late 1940s, Mr. C.T. Williams, Mr. Moses Ridley, Mr. James Rogers, and Mr. Vernell Simmons brought suit against Orlando mayor William Beardall, the city clerk, and officers of the White Voter's Executive Committee to force officials to permit African Americans to vote in Democratic Primary Elections. Mr. Williams worked closely with Harry T. Moore to increase the number of African Americans voters in Orlando. On October 3, 1950, the first primary open to all races was held in Orlando. Mr. Williams owned a dry cleaning and shoe repair shop, and he is shown inside his business.

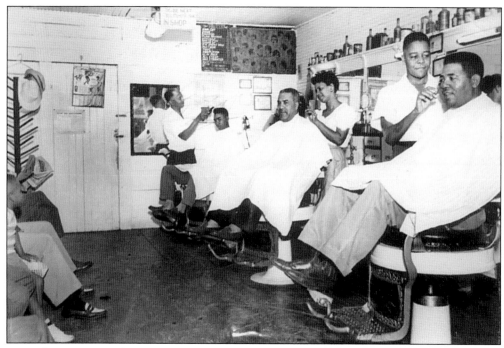

Mr. Holloman serves clients at his barbershop at 505 W. South Street.

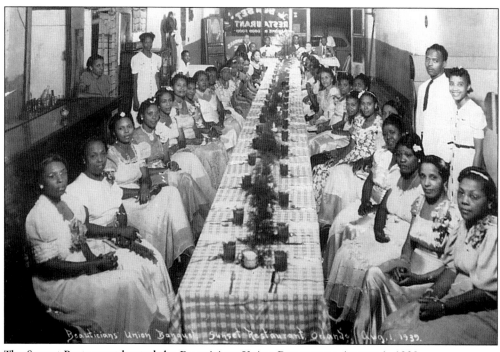

The Sunset Restaurant hosted the Beauticians Union Banquet on August 1, 1939.

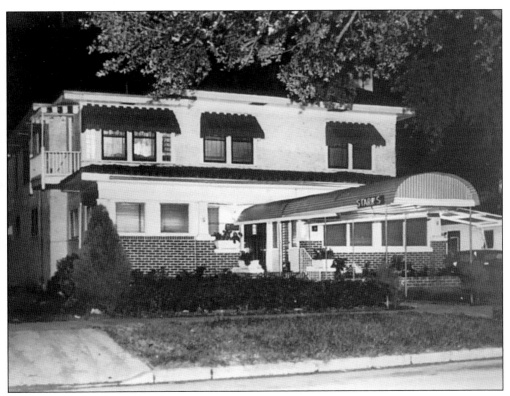

Starks Funeral Home operated at 414 N. Westmoreland Drive.

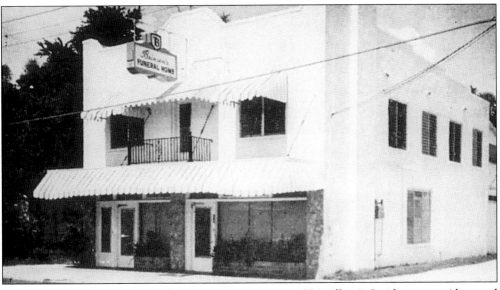

Brinson's Funeral Home opened at 719 S. Parramore in 1921. Allen J. Smith was president and A.C. Brinson was secretary/treasurer. Employees included Charlie Barksdale, Ruby Sanders, Altamese Taylor, Ulysses Baker, B.T. Sirmons, and George Harris. Ambulances did not provide service to the African-American community, so hearses from Brinson's Funeral Home doubled as ambulances.

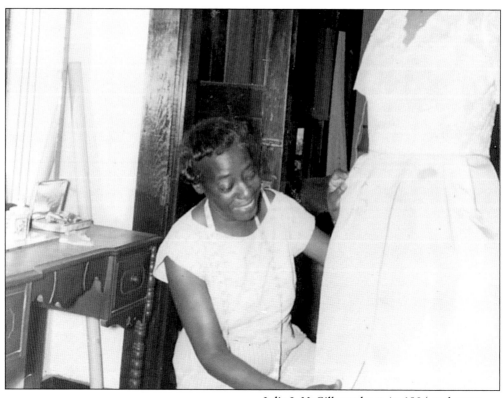

Julia I. McGill was born in 1904 and came with her family to Orlando in 1917. She graduated from Jones High School and attended Morris Brown College where she majored in dress design and tailoring. She was employed in the fashion district of New York near Fifth Avenue. She returned to Orlando and worked as a seamstress for Dickson and Ives, one of the city's largest retailers. She initially worked evenings and weekends in her home and did such a thriving business that she decided to devote her full time and effort to her enterprise. She is shown above with one of her creations.

Mr. Marion Price, known as M.P., managed the South Street Casino for a time with his brother, A.C. After a fire destroyed a major portion of the South Street Casino, the operation moved next door onto the ground floor of the Wells'Built Hotel. It then became known as the Quarterback Club.

Seven

COMMUNITY UPLIFT

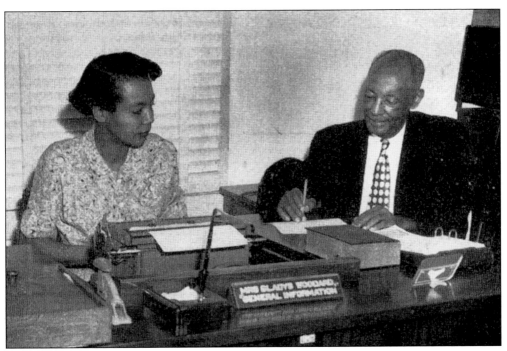

Mrs. Gladys Woodard, secretary of the Negro Chamber of Commerce, consults with Mr. Z.L. Riley, president of the Negro Chamber.

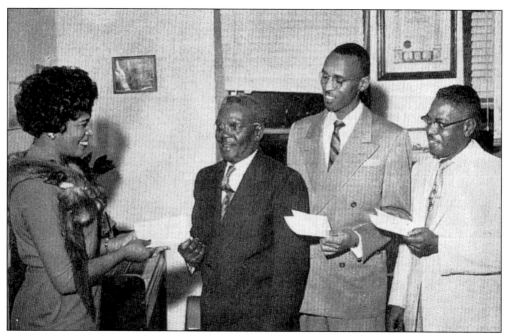

Neighborhood beautification was a high priority in the African-American community. Mrs. Patricia Butler is shown presenting checks to first-, second-, and third-place winners in the 1957 Christmas lighting and decorations contest. The winners were Charlie Reed, James "Chief" Wilson, and Herndon G. Harrison.

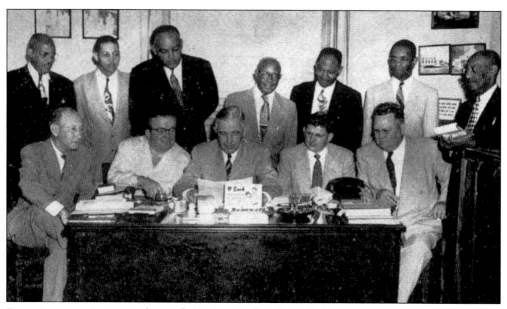

Executive committee members of the Negro Chamber of Commerce participated in budget sessions with members of the Orlando City Council. Sitting from left to right are Robert L. Williams, E.B. Moses, W.M. Beardall, W.H. James, and Walter C. Bass. Standing from left to right are Alvie Whittington, W.H. Strong, James B. Walker, Dr. William Monroe Wells, Ernest Holloway, C.J. Coleman, and Z.L. Riley.

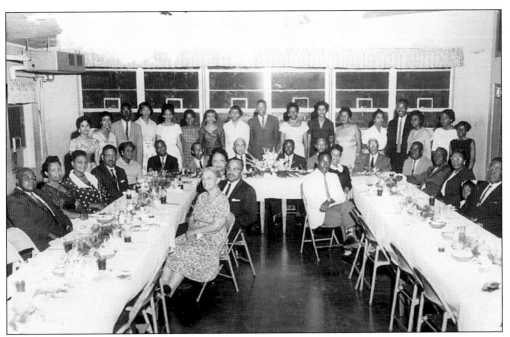

African-American leaders met to address community concerns in the 1950s. Among those identified in this photograph are L. Claudia Allen, Rufus Brooks, Arthur "Pappy" Kennedy, Mrs. Mary Hodge, Mr. Felton Johnson, and Mr. Cecil Boston.

Mr. Rudolph V. Gripper was an educator at Jones High School and a committee man with the Negro Chamber of Commerce.

Mr. Zellie L. Riley was executive secretary and manager of the Orlando Negro Chamber of Commerce. He constructed the Riley Building in 1946 to house his tailoring business and the chamber.

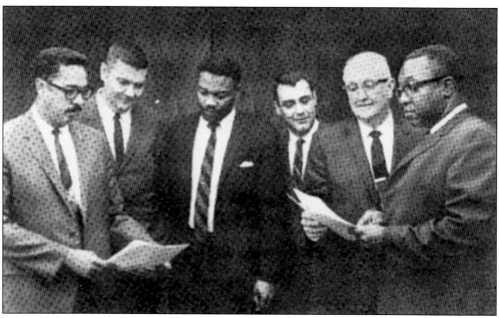

The Orlando Area Chamber of Commerce established a minority business sub-committee. The individuals shown above attended a meeting on August 17, 1969. From left to right are Lonnie Brown, Richard Junkins, Norris Woolfork, Harry Becker, Allen Smith, and Royce Walden. (Courtesy Norris and Marjorie Woolfork.)

Miss Susie M. Counts was crowned Miss
Negro Chamber of Commerce in 1952. She
competed successfully in a drive to enroll
the most individuals as members of the
Negro Chamber of Commerce.

The American Savings Building and Loan
Association and the Negro Chamber of
Commerce sponsored a scholarship for
Jones High School graduates. Barbara Jean
Speight, a 1955 graduate, accepts a $400
scholarship check. Pictured from left to
right are Principal Cecil Boston, J.R. Caton
from the Loan Association, Miss Speight,
and Mr. Z.L. Riley.

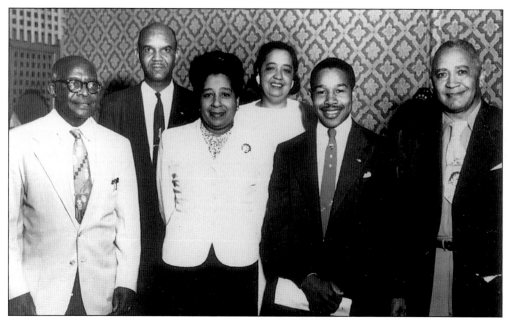

Leaders in the African-American community often met to discuss concerns in the area and to propose solutions for identified problems. Pictured in the 1950s, from left to right, are (first row) Dr. William Monroe Wells, Mrs. Thelma M. Speight, Atty. Paul C. Perkins, and Dr. I. Sylvester Hankins; (back row) Bethune Cookman College president Dr. Richard V. Moore and Mrs. Marguerite Rigsbee, hotel operator.

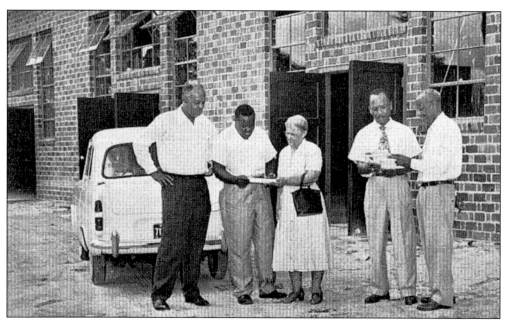

These members of the Washington Shores Park Committee look over a list of equipment needed for the new community center. Pictured are Mr. James B. Walker, Rev. E.A. Jupiter, Mrs. Mary E. Hodge, Mr. Felix Cosby, and Mr. Zellie L. Riley. Mrs. Inez Fort and Mrs. Annie N. Crooms are not shown.

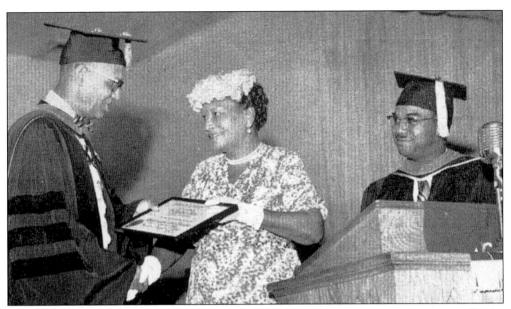

Bethune Cookman College president Dr. Richard V. Moore presented a citation to Miss L. Claudia Allen, supervisor of Negro Schools of Orange County, while Mr. J.E. Huger looks on.

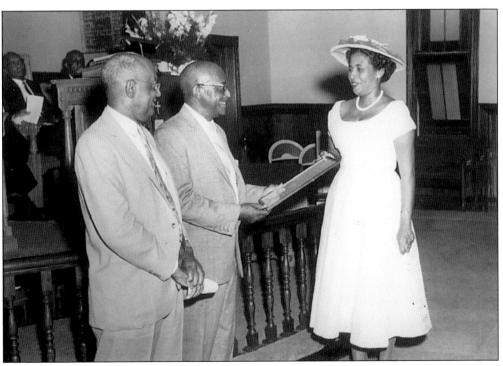

Mrs. Ernestine Emery was born on March 10, 1920. She attended Jones High School when it was located on Washington and Parramore from first through twelfth grades. Mrs. Emery received a Bachelor of Science in Physical Education from Bethune Cookman College and taught physical education at Jones High School for more than 57 years. She is shown here in the 1940s presenting a plaque of appreciation to Dr. William Monroe Wells.

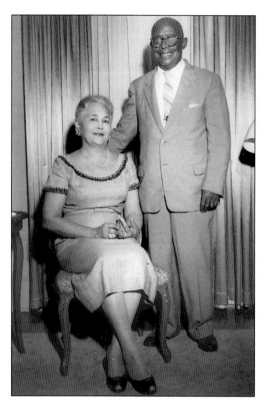

Clifford Irene Wells was born in Ft. Gaines, Georgia to parents who were just out of slavery. Her parents cultivated a small family-owned plantation and encouraged their daughter to go to school and get as much knowledge as possible. In Orlando, Mrs. Wells involved herself in civic work and community service. She was a charter member of the Links, Inc. Orlando Chapter, which was organized in 1952. Mrs. Wells is shown here with her husband, Dr. William Monroe Wells.

Mrs. Bluette Jenkins was the first African American social worker in Orlando. Employed by the Florida Department of Welfare in 1937, she organized the Negro Welfare Planning Council, which later became a part of United Community Service. She was a Committee Woman with the Orange County Democratic Executive Committee. She and her husband, Osborne Jenkins, often took children into their home in the absence of foster homes for Negro children. She organized a Pink Ladies Auxiliary for the Dr. P. Phillips Hospital for Coloreds and served on the Forestry and Parks Board where she recommended that a park in Washington Shores be named to honor Dr. I. Sylvester Hankins.

Eight

CAMARADERIE AND PLEASANT PURSUITS

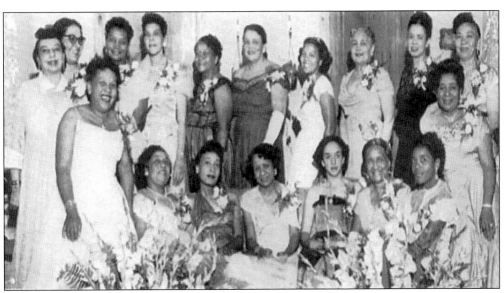

In 1952, Links, Inc., one of the premiere service organizations in the nation, established a chapter in Orlando. Leola G. Nixon organized the group and invited some of the most accomplished women in the city to join. Charter members of Links, Inc. Orlando Chapter include Leola G. Nixon, L. Claudia Allen, Linda Reddick, Bertha Scales, Georgia Schanck, Bettye Smith, Thelma M. Speight, Edith Starkes, Clifford Irene Wells, and Ethel Wooden. Linda Reddick is seated first on the right.

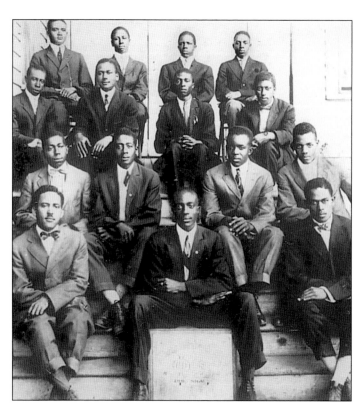

Dr. I. Sylvester Hankins Jr. is shown here with fellow members of his fraternity, Alpha Phi Alpha.

Members of Phi Delta Kappa welcomed Mr. Jesse Blayton to a career conference in 1963. Identified among those pictured below are Eddye K. Walden, Hattie Mitchell, Kattie Vereen, Minnie Woodruff, Jesse Blayton, Virginia Wilson, Mary Morall, Audrey Williams, and Dorcas Rose.

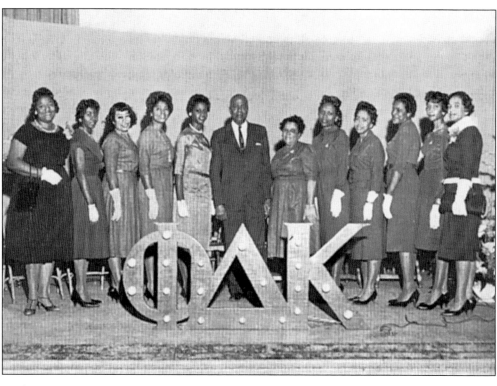

Members of the Orlando Chapter of Jack & Jill of America, Inc. are shown in 1963. Mrs. Alvane Forrest was president of the chapter. Pictured from left to right are Patricia Warren, Max Starks, Vera Adams, Kim Clark, Vickie Felder, Yvette Carter, and young Starkes.

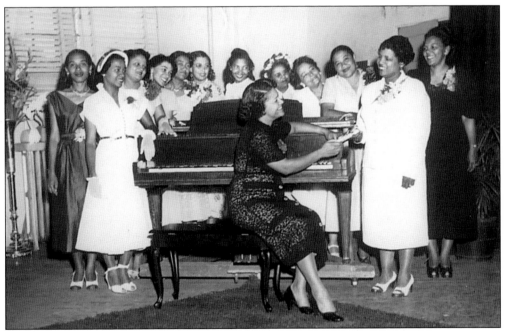

Members of the 1951 Delta Omicron Omega Chapter of Alpha Kappa Alpha Sorority, Inc. honored Mrs. Georgia Lee Wallace for her humanitarianism. Among those pictured are Mildred Board, Opal Bowles, Marie Gladden, Lilliam Hall, Susie Jackson, Flossie Lawson, Clara Mitchell, Eleanor Moore, Georgia Schanck, and Leslie Weaver.

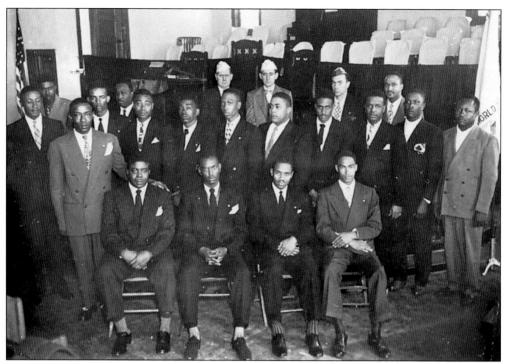

Mr. Bill Williams was an early member of AMVETS Post 30. The group is shown here.

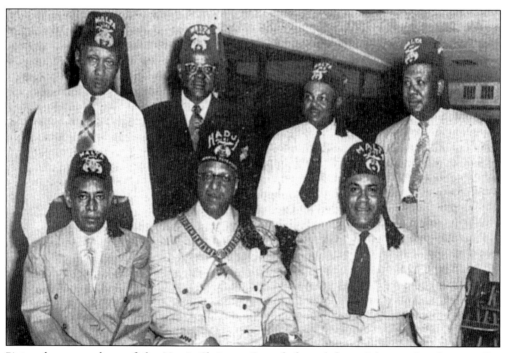

Pictured are members of the Mystic Shriners. Seated, from left to right, are Joe Stevens, Dr. Raymond E. Jackson, and Osborne Jenkins. Standing, from left to right, are Ivory Green, G.W. Fort, Eddie White, and Booker Alexander.

The Ever Ready Club was founded in 1944. Seated, from left to right, are Mrs. Melita Wright, Mrs. Pinkie Price, Mrs. Marguerite Rigsbee, Mrs. Curley Walker, and Mrs. Lila McDuffie. Standing, from left to right, are Mrs. Rubye Sanders, Mrs. Ollie Whitehurst, Mrs. Minnie Lee Branch, and Mrs. Bennie Stanley.

The Woman's Auxiliary of the Floyd Miller Post No. 30 are shown here. Standing, from left to right, are Mrs. Doris A. Miller, Mrs. Corinta Ward, Mrs. Gertrude Hering, Mrs. Edna Hood, Mrs. Sallie Fuce, Mrs. Ollie C. Martin, Mrs. Cracie Chatham, Mrs. Ivery Walker, Mrs. Nina Hall, Mrs. Ann Jackson, Mrs. Nellie Allen, Mrs. Josie Bell Jackson, Mrs. Virginia Bass, Mrs. Estella Williams, Mrs. Rutha Mae Epkins, Mrs. Rubye Potter, Mrs. Connie Muphy, and Mrs. Mary Penson.

The Orlando Chapter of Jack and Jill of America, Inc. is pictured here. Seated in the first row, from left to right, are Mrs. Alvane Forrest, Mrs. Nareda Hunt, Mrs. Adrienne Harrison, Mrs. Thelma Watson, and Mrs. Martha Carter. Seated in the second row are Mrs. Gladys Woodard, Mrs. Susie Jackson, Mrs. Mildred Brewer, and Mrs. Vivian Boston. Standing are Mrs. Guretha Courtney, Mrs. Beatrice Bruton, Mrs. Beatrice Davis, Mrs. Peggy Jones, Mrs. Elease Simon, Mrs. Ernestine Parker, Mrs. Harriette Bell, Mrs. Dora Anderson, Mrs. Ruth Rogers, Mrs. Clara Williams, Mrs. Martha Walton, Mrs. Annie Ruth Johnson, and Mrs. Leora Walker. Not shown are Mrs. Ollie Richardson, Mrs. Ruby Rich, Mrs. Audrey Ellis, and Mrs. Louise Brinson.

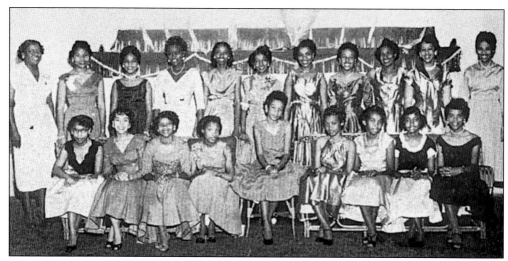

The Gay Teeners Club was organized in 1950. Shown standing, from left to right, are Thelma Jackson, Beverly McGowan, Jacquelyn Bradshaw, Alzada Maxwell, Adelma Edwards, Willie Lee Mims, Thelma Burns, Gloria Williams, Leona Burns, Bessye Banks, and Juanita Johnson. Seated, from left to right, are Eleanor Hayes, Barbara Speight, Mary Davis, Phyllis Batson, Alfreda Woodruff, Eula Mae White, Della Dunn, Barbara Lucas, and LaFrance Kleckley.

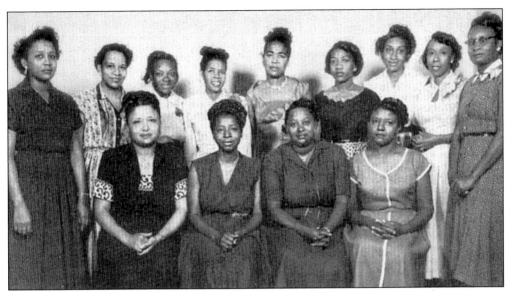

The Moderneers Club was founded in 1942. Seated, from left to right, are Mrs. Marian E. Kennedy, Mrs. Essie M. Whittington, Mrs. Thelma M. Watson, and Mrs. Annie M. Felder. Standing, from left to right, are Mrs. Beatrice B. Bryant, Mrs. Dorothy A. Mitchell, Mrs. Eva Towns, Mrs. Josie Belle Jackson, Mrs. Reva M. Wilkins, Mrs. Clara C. Mitchell, Mrs. Beatrice Bryant, Mrs. Floretta C. McKenzie, and Mrs. Ollie C. Martin. Mrs. Susie E. Jackson and Mrs. Ruth M. Kleckley were not pictured.

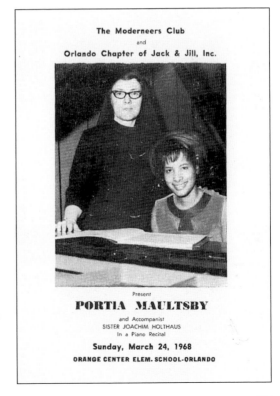

The Moderneers Club collaborated with other groups to provide social and cultural activities for the Orlando community. On March 24, 1968, the Moderneers Club presented a piano recital featuring Ms. Portia Maultsby.

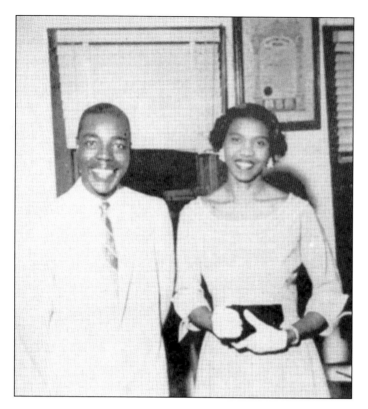

Mr. Harry Morrall and Mrs. Dorthea Starks served as judges in the 1956 Christmas lighting and decordation contest. In 1958, Mrs. Starks's husband, George, became the first African American admitted to the University of Florida College of Law.

Bill Williams, the son of C.T. Williams, performed in minstrel shows. Williams's family members entertained surrounding neighbors such as the Hensons, McClendons, Argretts, Bozemans, and Blackmans.

Bill Williams and his brother are shown here in a minstrel show in the 1920s. The Williams family lived near Division and Carter. Bill purchased sheet music, which was played on the piano by his sister, Margaret, who took piano lessons from Ms. Melita Jones. The family hosted 10-cent socials at their home, which was a popular gathering place for youngsters.

A successful day of fishing ends with a handsome catch.

Mr. Mel Butts is pictured in 1918 showing off a prized catch. Fishing was a major past time in the area.

Mr. Booker T. Reddick was a football coach for 38 years. He coached basketball for 20 years and experienced his greatest success at Phyllis Wheatley where a "B" class of 90 boys from grades 9 through 12 won 16 regular-season games. The 1958 Phyllis Wheatley basketball team took third place in the National Basketball Championship of the United States. Pictured from left to right are (front row) Charles Jackson, Simuel Burrell, Clifford McKenzie, Hubert Graham, Freddie Filmore, and Marion Price; (back row) D.D. Jackson (coach), James Webb (trainer), Lary Rozier, Paul Fair, Fred Pollard, James Rouse, Ossie Cannon, Willie Thomas, Ernest James, Booker T. Reddick (head coach), and George W. Fort (principal). (Courtesy Linda Reddick.)

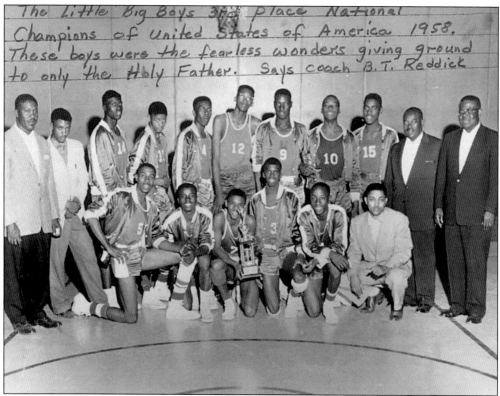

Clyde on a Cloud of station WLOF, a popular DJ in Orlando, was the first African American in the city to work as a radio announcer.

Many Orlandoans were great sports enthusiasts and championship athletes. Shown above are Howard Miller, Wilbur Gary, and Razzie Smith. Wilbur Gary later became principal of Jones High School.

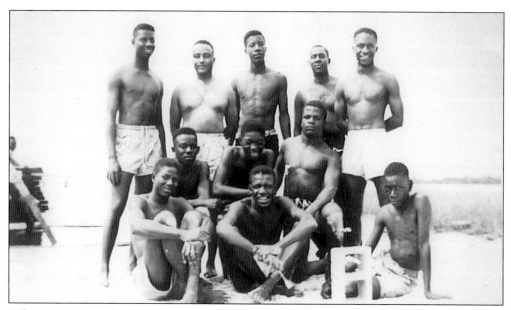

Gilbert McQueen and others participated on a swim team organized by businessman Wolf Kahn to reduce drownings among African-American youth who were barred from public swimming pools. They were trained in life-saving techniques. Gilbert McQueen, who was killed during the Korean War, stands first on the left. (Courtesy Wolf Kahn.)

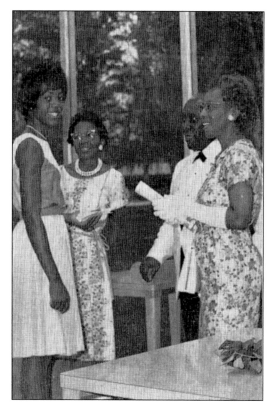

The Negro Chamber of Commerce sponsored Miss Barbara Page in the 20th Century Contest in 1963. Pictured with Miss Page are Angenola Adams, Kenneth Roane, and Mrs. Roane.

Vivian Jordan Carrington was an outstanding athlete who participated in bowling, tennis, soccer, horseshoes, volleyball, horseback riding, track and field, karate, weight lifting, skating, racquetball, aerobic dancing, and swimming. She spearheaded the first drill team at the new Jones High School location where 100 girls were involved. She is an ordained minister and an Ancient Matron of Heroines of Jericho Gardenia Court 10.

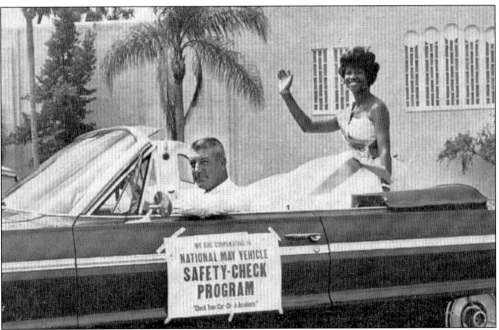

Miss Jacquelyn Farrington waves in the Auto Safety Check Parade after being chosen "Safety Queen" in 1964.

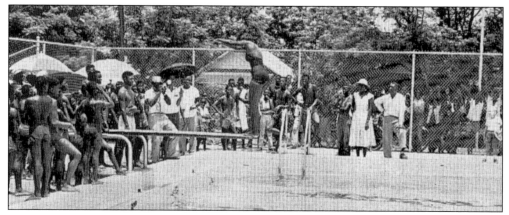

Young people participated in swimming meets at the Carter Street Pool. The young woman on the diving board is preparing to do a backwards flip.

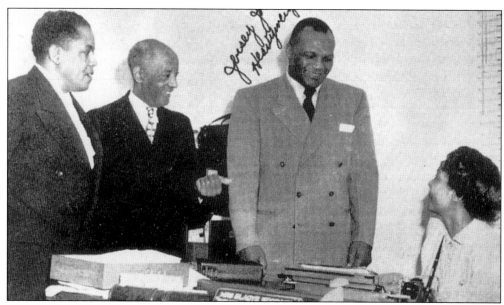

African-American visitors to Orlando in the early 1950s visited the Negro Chamber of Commerce to get information on things to do and see. Heavy-weight champion Jersey Joe Walcott visited in 1952.

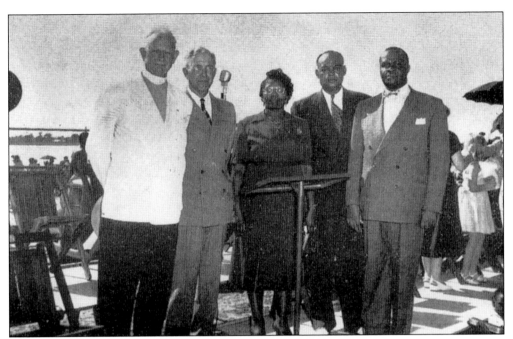

Orlando citizens celebrated the opening of the Gilbert McQueen Beach, which was a park-like facility created along Lake Mann. This was a swimming and recreational area for African Americans before public pools were open to them. Pictured during the dedication ceremony are Dean Melville Johnson, Mr. R.V. Gripper, Mr. James B. Walker, Mayor W.M. Beardall, and Mrs. Catherine McQueen, the mother of Gilbert McQueen.

After retiring as head choach from Jones High School, Booker T. Reddick directed activites at the L. Claudia Allen Center. He is shown here presenting trophies to individuals who were studying golf at the center. (Courtesy Linda Reddick.)

Vivian Carrington served the area as a swimming instructor for 31 years at facilities including Hankins Park, the Cat Cadogan Home, the Downtown YMCA, and Lake Lorna Doone. She carved her nickname into the cement before the opening of the Carter Street Pool, which was the first public swimming pool built for African Americans in the City of Orlando. She worked as a lifeguard and swimming instructor there for four years. She is seated second from the right.

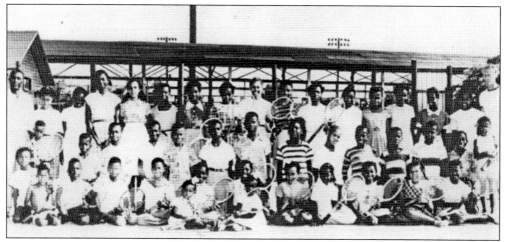

Vivian Jordan Carrington, better known as "Miss Vip," began playing tennis at the age of nine at the Carter Street playground. She stands in the center of a group of tennis players at the Carter Street playground, now known as the John Jackson Center named for Orlando's first supervisor of African-American recreation.

Nine

DEFENDING RIGHTS AND PROMOTING OPPORTUNITIES

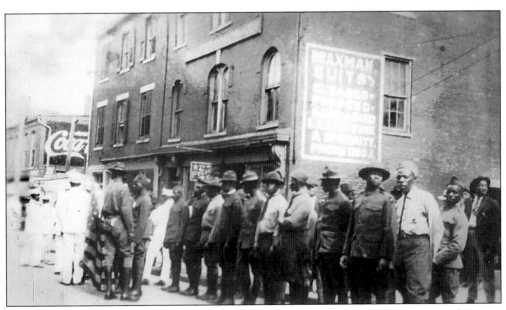

African Americans have served in all of America's wars beginning with the sacrifice of Crispus Attucks in 1770 at the start of the Revolutionary War. African-American veterans are shown here in Orlando on Memorial Day.

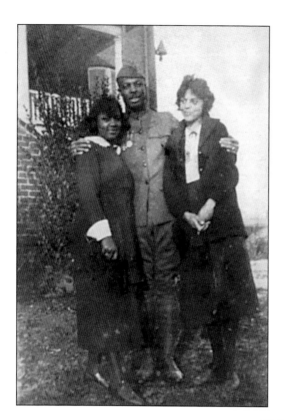

A World War I soldier visits family and friends on a trip home.

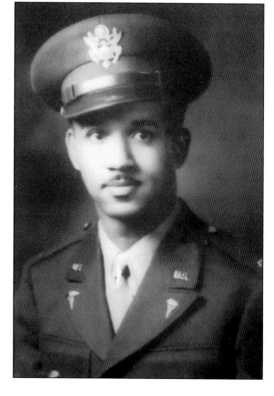

George Pervel Schanck is shown in service to his country. He served as a captain in the 92nd Infantry of the United States Army from 1943 until 1946 and in the medical corps where he specialized in neuropsychiatry. President Ronald Reagan recognized his sacrifice.

The Presidential certificate awarded to George P. Schanck is depicted here.

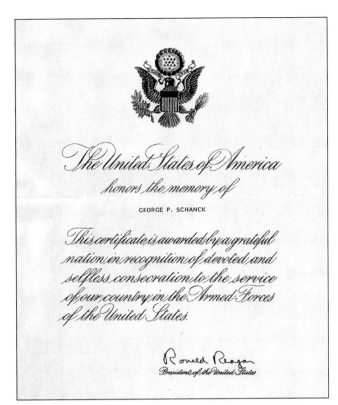

J.P. Ellis socializes with other aviation cadets in the barracks at Tuskegee. (Courtesy Audrey Ellis Tillinghast.)

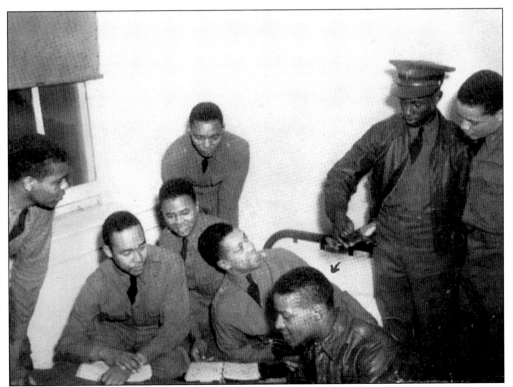

Harry A. Sheppard	Luther H. Smith, Jr.	John J. Suggs	James A. Walker	Dudley M. Watson	Laurence D. Wilkins	Craig H.

STUDENT OFFICERS
CLASS 43-F

Milton R. Henry
Second Lieutenant

Osie R. Walton
Second Lieutenant

CLASS 43-F
CADETS

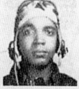

R. M. Alexander, Jr.

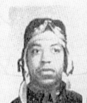 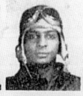 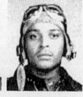

James L. Arnold	C. C. Bivens, Jr.	Joseph M. Bloedoorn	Alexander M. Bright	Robert T. Buck	Broadus N. Butler	Charles R. Ca

 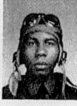

Eugene Cash, Jr.	Joseph C. Curry	Logan D. Delany	Crawford B. Dowdell	J. P. Ellis	Warren H. Eusan	Terry D. G

J.P. Ellis was a member of the Tuskegee Airmen. The first group of aviation cadets reported to Tuskegee in 1941 and received instruction from general manager of the school, George L. Washington, an MIT graduate. This photograph was taken at the Tuskegee Army Flying School

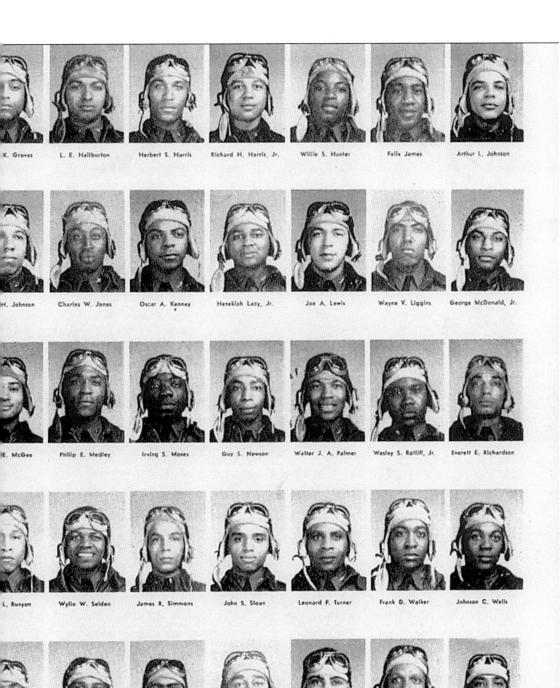

| K. Groves | L. E. Hailburton | Herbert S. Harris | Richard H. Harris, Jr. | Willie S. Hunter | Felix James | Arthur L. Johnson |

| H. Johnson | Charles W. Jones | Oscar A. Kenney | Hezekiah Lacy, Jr. | Joe A. Lewis | Wayne V. Liggins | George McDonald, Jr. |

| E. McGee | Philip E. Medley | Irving S. Moses | Guy S. Newson | Walter J. A. Palmer | Wesley S. Ratliff, Jr. | Everett E. Richardson |

| L. Runyon | Wylie W. Selden | James R. Simmons | John S. Sloan | Leonard F. Turner | Frank D. Walker | Johnson C. Wells |

| Whitlow, Jr. | William G. Wilkerson | Albert P. Williams | Felix A. Williams | Harrison A. Williams | William F. Williams, Jr. | Theodore A. Wilson |

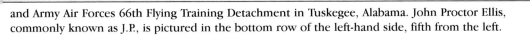

and Army Air Forces 66th Flying Training Detachment in Tuskegee, Alabama. John Proctor Ellis, commonly known as J.P., is pictured in the bottom row of the left-hand side, fifth from the left.

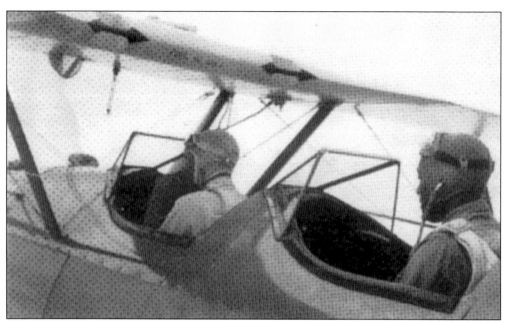

J.P. Ellis is shown in the second seat of this plane at Moton Field at Tuskegee. (Courtesy Audrey Ellis Tillinghast.)

J.P. Ellis watches as other aviation cadets prepare for flight. (Courtesy Audrey Ellis Tillinghast.)

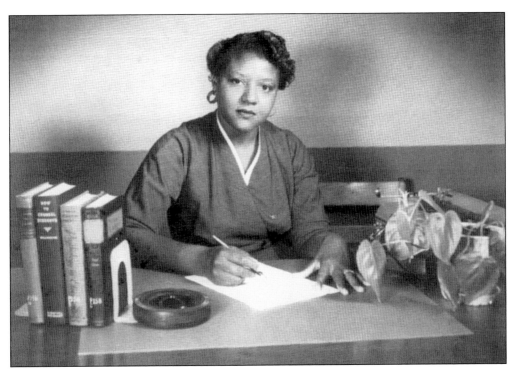

Anne Mitchell Felder was born in 1915 and received a B.A. degree from Florida A&M University in 1937. She served as a WAC for four years. She is a Disabled American Veteran and a life member of Delta Sigma Theta Sorority. She was an educator in Orlando for more than 25 years.

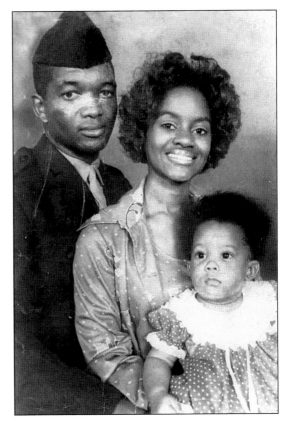

An Orlando military man and his family are shown here.

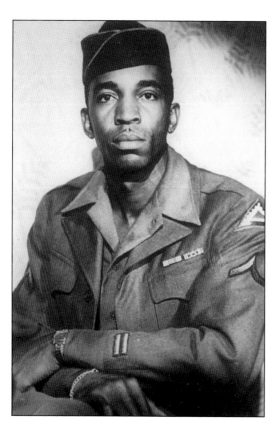

Mr. Dilworth Guinyard is shown here as he served America.

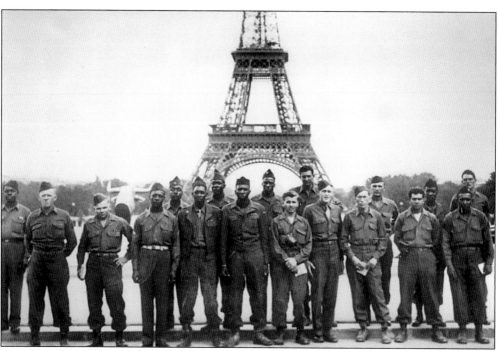

Dilworth Guinyard and others are shown overseas during World War II.

116

Atty. James Collier, who was born in Florida in 1920, began his law practice in the Carver Theatre in Orlando in 1951. He grew up in Orlando, where his father, Rev. T.C. Collier, pastored the Shiloh Missionary Baptist Church for more than 30 years. He was a graduate of Howard University Law School and was admitted to practice before the Florida and United States Supreme Courts, as well as the United States District Court and the United States Court of Appeals. The African American Law Student Association at Barry University Law School in Orlando is named to honor James A. Collier.

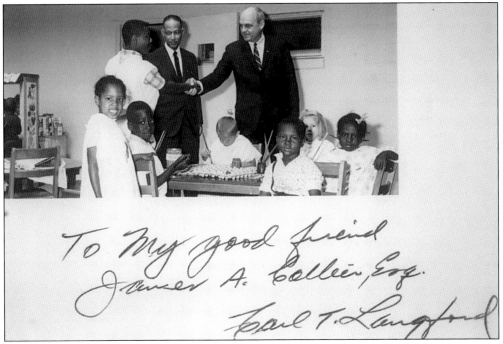

Orlando mayor Carl Langford greets young people with Atty. James Collier, whom he appointed to head an inter-racial advisory council. The council was organized to address race relations and issues of discrimination locally during a time when many cities were hard pressed to deal with riots and racial tensions. James A. Collier recommended the formation of the Orlando Human Relations Department, which was established in 1972.

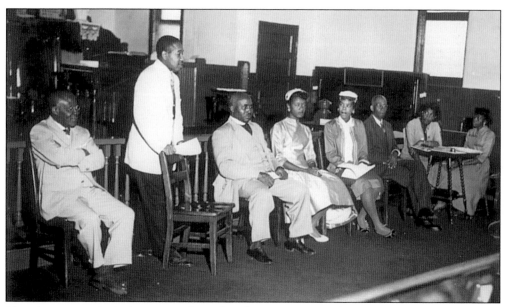

Churches were principal meeting places for African Americans during the Civil Rights struggle. Atty. Paul C. Perkins is shown here speaking to a group at church. He opened his law practice in Orlando in 1951 and almost immediately became co-counsel to Thurgood Marshall, who was sent by the NAACP to defend four young black men accused of raping a white woman in nearby Groveland. Paul Perkins later served as a City of Orlando prosecutor and a judge in the town of Eatonville. He was a life member of the NAACP.

Norris Woolfork began his legal practice in Orlando in 1961, three years after graduating from Howard University Law School. In 1962, on behalf of J.P. and Audrey Ellis, he filed suit against the Orange County Board of Public Instruction to force the integration of schools in Orange County. He was an organizer of the Florida Chapter of the National Bar Association, a member of the City of Orlando Human Relations Board, and one of the first presidents of the Metropolitan Orlando Urban League, which was organized in 1977. As a result of the suit pursued by Norris Woolfork, schools in Orange County were integrated in 1970, 16 years after the Brown v. Board decision was rendered that struck down segregation in public schools. (Courtesy Norris and Marjorie Woolfork.)

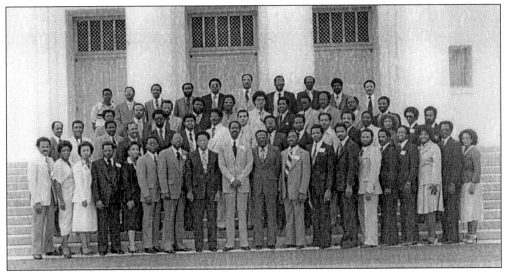

Orlando lawyers Paul C. Perkins, James A. Collier, and Norris Woolfork helped to organize a group of African-American attorneys statewide in the 1950s to address legal issues throughout Florida. The original members of the group, known as Chi Epsilon Legal Fraternity, affiliated with the predominantly black National Bar Association. Years later, members voted to change the name of the organization to the Virgil Hawkins Florida Chapter of the National Bar Association in honor of Virgil Hawkins, who filed suit in 1949 for the right to attend law school at the University of Florida. Members of the group are shown in the early 1970s. Emerson R. Thompson Jr. stands on the bottom row, sixth from the right. (Photograph by Steve Beasley, courtesy of Emerson R. Thompson Jr.)

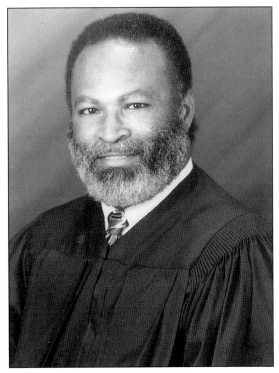

Emerson R. Thompson Jr. came to Orlando in 1972 as the first African American employed by the State Attorneys Office. Gov. Rueben Askew appointed him Orange County Court Judge in 1976. Gov. Bob Graham appointed him to the circuit court in 1980. He became chief judge of the circuit court and in 1993, Gov. Lawton Chiles appointed him to Florida's Fifth District Court of Appeals where he would also serve as chief judge. (Courtesy Emerson R. Thompson Jr.)

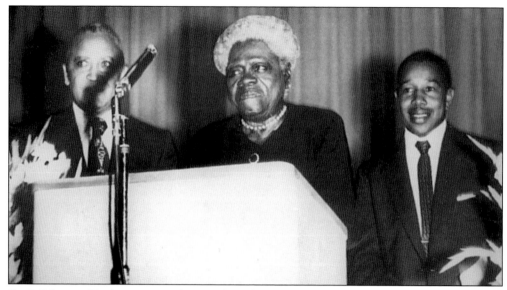

Dr. I. Sylvester Hankins Jr., standing to the left of Dr. Mary McLeod Bethune, hired Atty. Paul C. Perkins in 1951 to sue the Orange County Board of Public Instruction to force that body to build a larger facility for the overcrowded Jones High School. A year earlier, white voters had approved a $6 million bond issue to build new high schools. All of the funds were earmarked for Edgewater and Boone High Schools, which would open as segregated facilities. Paul C. Perkins filed the suit on behalf of Dr. Hankins, Mr. Z.L. Riley, Dr. William Monroe Wells, Mr. W.B. Bozeman, and Rev. N.G. Staggers. As a result, a new $1 million school for Jones High students opened in 1952. Attorney Perkins stands to the right of Dr. Bethune, a champion for education.

John Proctor Ellis, commonly called J.P., was president of the Orange County Branch of the NAACP in the early 1960s. He taught woodworking at Jones High School and brought a lawsuit in 1962 on behalf of his daughter, Evelyn, to permit her to attend segregated Boone High School. J.P. Ellis was a graduate of Florida Memorial College, and he studied aviation at the Tuskegee Army Flying School of the Army Air Forces Southeast Training Center. The Tuskegee Cadets were members of a segregated flying unit who later became known as the Tuskegee Airmen.

Audrey Ellis graduated from Bethune Cookman College in 1950. She taught school at Hannibal Square in Winter Park and, with her husband J.P., often entertained Thurgood Marshall in her home. J.P. Ellis was one of the first African Americans in Central Florida to be granted a general contractor's license and he constructed a beautiful home for Audrey and their children. Audrey and J.P. Ellis are shown here. (Courtesy Audrey Ellis Tillinghast.)

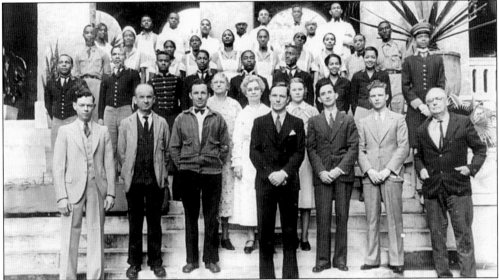

Arthur Reen Kennedy, commonly called Pappy, was born in Florida on December 8, 1913. He came to Orlando in 1928 and lived with his uncle on W. Jackson Street. Because of the relatively few scholarships available to African Americans to support study beyond high school, Arthur "Pappy" worked numerous jobs to support himself and save money for college. He cut yards, washed windows, picked up bottles to sell, worked in a supermarket, and served in a hotel at the Orange Court Motor Lodge. Managers at the Orange Court Motor Lodge sent Pappy to Tuskegee Institute to study hotel management. He organized a system for checking in guests, managing the kitchen, and performing clerical duties. Pappy became head bellman at the Orange Court Motor Lodge. Using funds from his various jobs, he sent himself to Bethune Cookman College. Pappy is pictured in the second row, third from the left with other staff members of Orange Court.

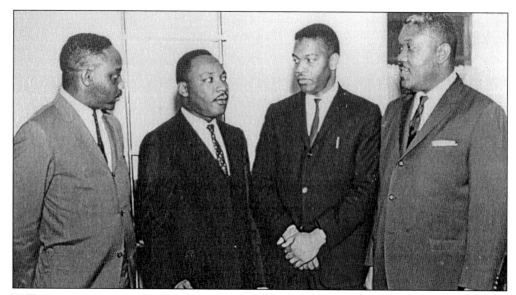

Willie James Bruton was born in Orlando in 1926. He graduated from Jones High School and attended Florida A&M University. He served in the Philippines in World War II before completing studies at Echols Mortuary School in 1946. He began his work in Orlando as an apprentice at Starks Funeral Home. In the early 1960s, he built a $50,000 funeral home on Vineland Road. In 1977, Mr. Bruton organized and served as the first president of the Metropolitan Orlando Urban League. He was a life member of the Orange County Branch of the NAACP, a trustee at Valencia Community College, and a leader at Shiloh Baptist Church. Mr. Bruton is shown here on the extreme right with Dr. Martin Luther King Jr. and other civil rights leaders. Also pictured are Dub Lewis and Norris Woolfork. Bruton Boulevard is named for Willie James Bruton.

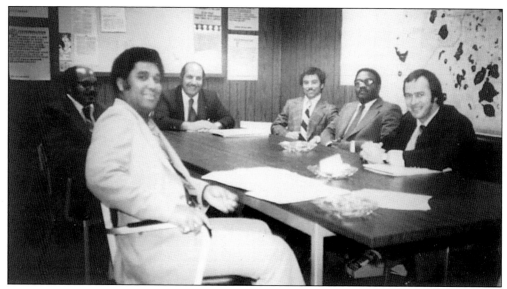

Bob Billingslea, who worked to provide equal employment opportunities at Walt Disney World, and Norris Woolfork, an NAACP lawyer and private practitioner, are shown with other members of an early Board of the Orlando Human Relations Department. The board provided guidance to the newly formed human rights office.

Ten

MOVING AHEAD

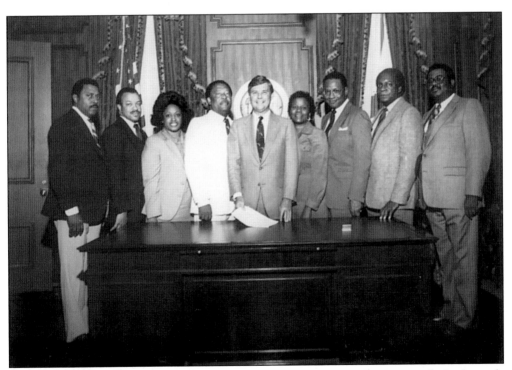

Single-member districts were established in Florida in the late 1970s. As a result, in the early 1980s, African Americans were elected to the Florida legislature in significant numbers. The class fo legislators pictured with Florida governor Bob Graham includes, from left to right, John Thomas, James Burke, Corrine Brown, Jeff Reaves, Carrie Meek, Alzo J. Reddick, Bill Clark, and Doug "Tim" Jamerson. Corrine Bown an dCarrie Meek were later elected to Congress. (Courtesy Alzo J. Reddick.)

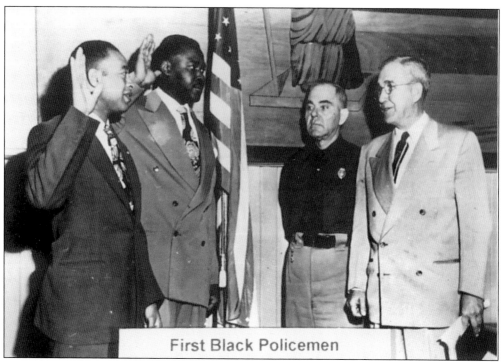

First Black Policemen

Belvin Perry Sr. and Richard Arthur Jones are shown in 1951 being sworn in as the first African-American police officers for the City of Orlando.

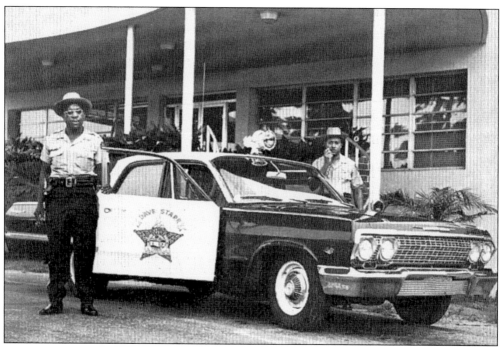

Deputy Leroy Williams and Deputy Louis Crooms were among the first African Americans to join the Orange County Sheriff's Department.

Arthur "Pappy" Kennedy was a highly regarded staff member at the Orange Court Motor Lodge and the popular Winter Park restaurant, the Beef and Bottle. He knew people in the African American and white communities of Orlando. Pappy Kennedy ran f or the Orlando City Council and won an at-large election in 1972 to become the first African-American in Central Florida elected to public office. Commissioner Kennedy is honored annually in Orlando during the Martin Luther King Jr. holiday.

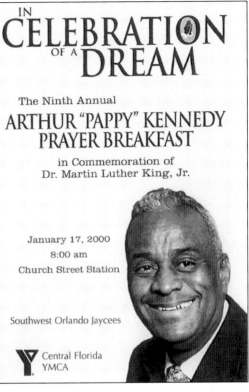

IN
CELEBRATION
OF A
DREAM

The Ninth Annual
ARTHUR "PAPPY" KENNEDY PRAYER BREAKFAST
in Commemoration of
Dr. Martin Luther King, Jr.

January 17, 2000
8:00 am
Church Street Station

Southwest Orlando Jaycees

Central Florida
YMCA

Albert Nelson graduated from Jones High School in 1955 and attended Johnson C. Smith where he received a B.S. in political science. He received a Masters in public administration from the University of North Carolina and served as a paratrooper in the 11th Army Airborne Division. Orlando mayor Carl Langford hired him in 1972 as director of human relations. Mr. Nelson was the first African-American director for the City of Orlando. From 1972 until he retired in 1999, Albert Nelson worked to open up opportunities for African Americans in the city and to promote civil and human rights throughout the country. Mr. Nelson, who is a member of Kappa Alpha Psi Fraternity and St. John the Baptist Church, is pictured here. (Courtesy Orlando Human Relations Department.)

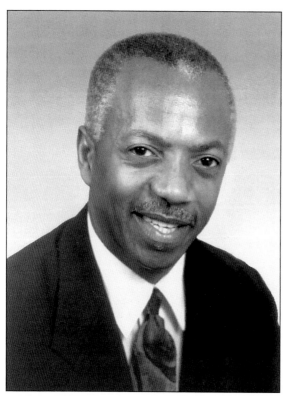

Ernest Page, a Morehouse College graduate, was elected to represent District 6 as a member of the Orlando City Council in 1980. He was one of two African Americans elected under a single-member district system. Commissioner Page pushed for greater utilization of minority-owned businesses in the City of Orlando.

Kattie Adams, a graduate of Jones High School, became the first African American to serve on the Orange County school board when she was elected in 1980.

Alzo J. Reddick, who grew up on W. Jackson Street in the Parramore area when it was the pride of black Orlando, became the first African American from Orlando elected to the Florida House of Representatives in 1982. He graduated from Jones High School and Paul Quinn College, and he served in the United States Army before returning to Orlando to work as an educator. As a legislator, he was the first African American in the history of Florida to introduce and see passed a constitutional amendment. Representative Reddick served from 1982 until 2000. (Courtesy Alzo J. Reddick.)

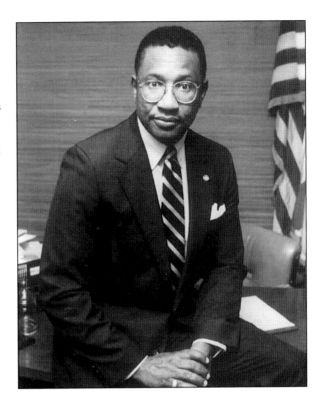

Napoleon "Nap" Ford was elected to represent District 5 as a member of the Orlando City Council in 1980. He was one of two African Americans elected under a single-member district system. Nap Ford was reelected in 1982 and 1986. He was elected Mayor Pro Tem in 1983 and 1984. (Courtesy Orlando Human Relations Department.)

Mable Butler provided services to the elderly through Meals on Wheels. She helped to organize the Metropolitan Urban League, was active in the NAACP, and was a moving force behind the creation of the Orlando Human Relations Commission, which she later chaired. In 1984, she became the first African-American female to serve on the Orlando City Council. She would later be elected to the Orange County Commission.

Florida governor Bob Graham appointed Geraldine F. Thompson to the Florida Commission on Human Relations. She served as a commissioner for 11 years. For seven of those years, Mrs. Thompson served as chair of that body. Geraldine and her husband, Emerson R. Thompson Jr., are actively involved in promoting equal opportunity throughout Florida. Mrs. Thompson directed equal opportunity efforts at Valencia Community College for more than 20 years. She is the founding president of the Association to Preserve African American Society, History and Tradition, Inc., which operates the Wells'Built Museum of African American History and Culture. She is shown standing with Gov. Bob Graham, who became a United States Senator and, in May 2003, announced his candidacy for President of the United States.